IMAGES
of America

CANDOR

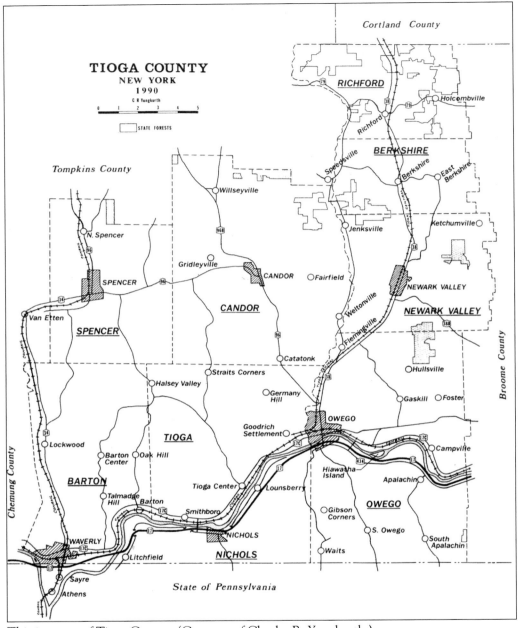

This is a map of Tioga County. (Courtesy of Charles R. Yungkurth.)

On the cover: Please see page 15. (Courtesy of the office of the Candor historian.)

IMAGES
of America

CANDOR

Carol A. Henry

ARCADIA
PUBLISHING

Copyright © 2008 by Carol A. Henry
ISBN 978-0-7385-6309-1

Published by Arcadia Publishing
Charleston SC, Chicago IL, Portsmouth NH, San Francisco CA

Printed in the United States of America

Library of Congress Catalog Card Number: 2008925212

For all general information contact Arcadia Publishing at:
Telephone 843-853-2070
Fax 843-853-0044
E-mail sales@arcadiapublishing.com
For customer service and orders:
Toll-Free 1-888-313-2665

Visit us on the Internet at www.arcadiapublishing.com

This book is dedicated with much love to my husband, Gary E. Henry Sr., for all the right reasons—patience, help, support—but mainly for his love and understanding in this and all my many projects.

CONTENTS

ACKNOWLEDGMENTS

There are several key people to thank for their assistance in creating this pictorial keepsake. Thanks to previous historian Donald F. Weber and those before him for their careful preservation of Candor's historic postcards and photographs that made this book possible. Also, thanks to Howard Weber for his help in verifying many of the images used in this book. A special thanks to Thomas McEnteer for the loan of many of the historic postcards and pictures from his personal collection. Thanks also go to Georgia Westgate, Sandy DePuy Brown, Cassie Haner Cortright, Milton and Patricia Dougherty, Jean Dougherty, Joan Cooke, Irene Cortright, Mary Haag, Dori Hyatt, Larry and Joan Beebe Meddaugh, Jean Alve, Howard Scharf, Janice Lohmeyer Swartz, and many others too numerous to include here for their contribution of an image, help identifying people, verifying facts, and especially for their friendship and support over the years. Unless otherwise indicated, all images are courtesy of the office of the Candor historian or the author.

And, as always, thanks, with much love, to my husband, Gary E. Henry Sr., for his endless help, patience, and support.

INTRODUCTION

Candor is a quiet, historical town. The first people came in 1794, but settlement is recorded as starting in 1796. The townspeople were industrious, religious, and educated people who immediately set up churches, schools, mills, and other industry and businesses as needed. Farming and timber were major occupations in the early days that kept the mills running. It was not until 1811 that Candor was redefined and separated from the town of Spencer. And in 1900, the two small villages of Candor Center and Candor Corners became the current village of Candor.

Like all small towns that grow with the changing times, so too did Candor. Still the community is best known as a bedroom community where most residents find work outside of the town. But Candor maintains many small- to mid-sized enterprises and mid- to large-sized farming and specialty farming operations and businesses today. Grown in proportion and notoriety are AA Dairy, Iron Kettle Farm, Side Hill Acres Goat Farm, Fallow Hallow Deer Farm, and several other dairy farms and organic vegetable farms. Many mills have gone by the wayside, but lumbering and feed mills are still a big part of Candor's diversity with Double Aught Lumber Company, Owego Contracting Company, and Hollenbeck's Feed Mill in Catatonk.

Steeped in tradition, Candor's Fourth of July celebration goes back to 1889. The annual Catatonk Canoe Regatta, Candor Chamber of Commerce Fall Festival of Events, Memorial Day parade, and other smaller annual events continue to make Candor a place to stop, visit, or find a place to call home. Churches are celebrating their 150th anniversaries, and Candor Central Schools, reported to be one of the top institutions in the area in the 1800s, still rank high in many of their educational and sports programs today. In fact, there are usually so many events happening in Candor at the same time that it is hard to pick and choose which ones to attend.

Famous or almost-famous people have left their mark on Candor. Kinney Street is a reminder that the founder of Kinney Shoes once walked the streets of Candor. Louis "Moondog" Harden called Candor and New York City his home, and even Harry Chapin wrote a song about the mayor of Candor. There are stories of movie stars like Walter Huston, well-known politicians like Theodore Roosevelt and Warren G. Harding, and even a ghost or two that has visited Candor.

In order to find out what really used to go on in the small town of Candor, the societal study by Arthur J. Vidich and J. Bensman, *Small Town in Mass Society: Class, Power and Religion in a Rural Community* (which called the town Springdale), had enough dirt on the townspeople of Candor in the 1950s that they retaliated by hanging Viditch in effigy in one of their Fourth of July parades. The book is in its third revision and is still being used at colleges and universities across the nation today.

Many families living in Candor have roots that go back to the early settlers, and it is almost too easy to find a relative of a relative that is willing to share stories of Candor in days gone by. With the many postcards from the early 1900s to those photographs taken by family and friends, this nostalgic glimpse of Candor and its surrounding neighbors should prove entertaining as well as educational for everyone.

One

BUSINESS AS USUAL

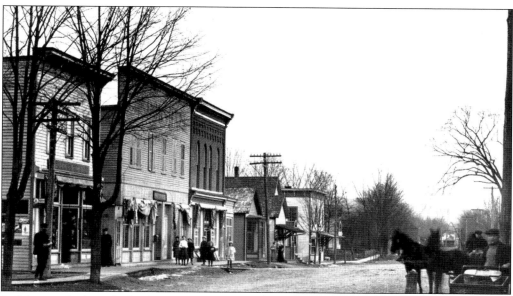

It did not take long for businesses to spring up along the main street in the new settlement of Candor. Likewise, the smaller communities sprinkled around the countryside in the town of Candor had businesses that served the needs of their neighbors. As transportation changed and school centralization took place in the 1930s so too did the needs of the people. Businesses came and went in an effort to keep up with the times. (Courtesy of Thomas McEnteer.)

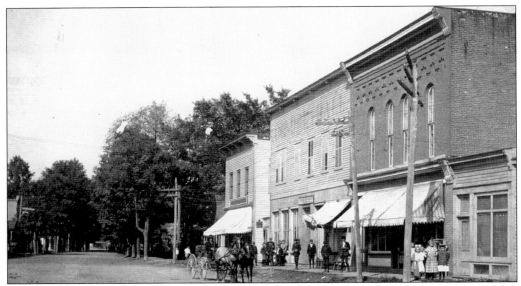

Young's Hall, pictured above at center, was built in 1875 along Candor Center's Main Street. After the hall burned in 1888, a group of people formed the Candor Hall Company and rebuilt the theater. Sometimes called the Candor Opera House, it continued as a cultural center until 1945 when it was sold and converted into a grocery store. Dewey's Furniture and Undertaking is located on the left of the town hall (above). To the right is Leon Ross and Bertha Bostwick's gift shop where young Margie LaGrange, Ruth Griffin, and Nettie Scharf are standing on the boardwalk. The same view below, taken years later, shows new automobiles. From left to right are Jennings' drugstore, Candor Hall, Miller's Furniture and Undertaking, an art store, a dry cleaner, a print shop, and a barbershop.

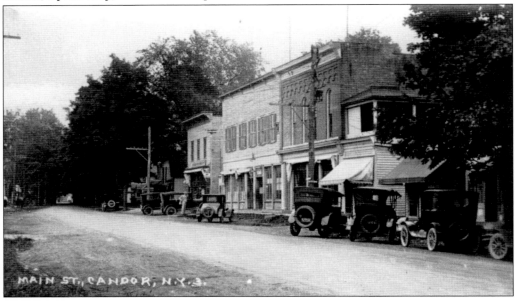

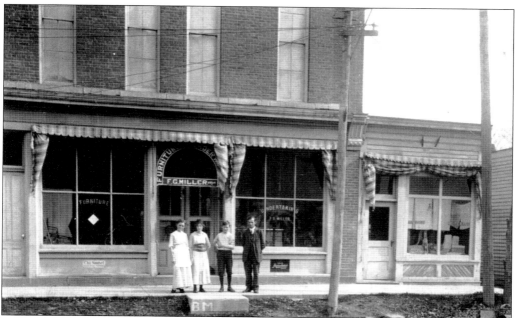

Fred G. Miller took over Dewey's Furniture and Undertaking business on Main Street around 1925. Pictured from left to right above are Eleanor Miller, Winifred, Myron, and Fred "Pop." This location later housed Mariette Seamon's dry goods store, Pete Cappiello's apothecary, and, for a few years, the Candor Central Schools district office. It is located next to the Candor Market (old town hall).

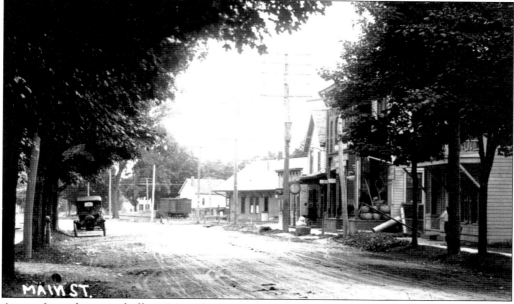

Across from the town hall on Main Street in the 1920s, several early businesses lined the dirt street where electric lines vied for space with the trees and the telephone poles. On the left at the end of the line of buildings is the Delaware, Lackawanna and Western Railroad depot. Started in the 1830s as the Ithaca–Owego Railroad, it pulled up tracks in the late 1950s.

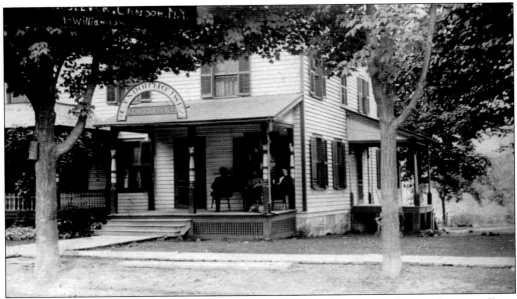

The Hotel St. Clair, located at 90 Main Street, had several owners and several names. For a time, it was the Candor Hotel and then Hotel Woolever. But the house was built in the 1800s and was owned by N. W. Griffin. In 1925, Fred G. Miller bought it and converted it into a two-family duplex.

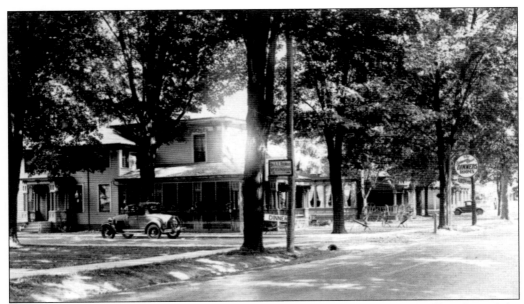

The Spinning Wheel Restaurant, originally the home of the Kinney family (founders of the Kinney Shoe Company), was located on the corner of Kinney and Main Streets. Students living in the surrounding farming communities often boarded here during the winter months in order to attend high school. The restaurant is now a home.

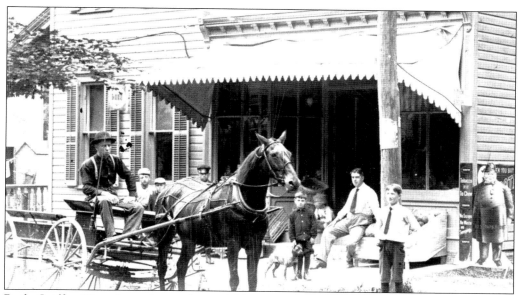

Ruth Griffin Warne's mother woke at 4:00 a.m. to bake bread for Jackson's Bakery in the early 1900s. Later Will Harding and then the Brown brothers ran the bakery. Thomas and Katherine Craig ran the Market Basket grocery here for a time, and in 1944, Winston Ives had his law office here. Other businesses have come and gone at this location, and today it is an apartment complex.

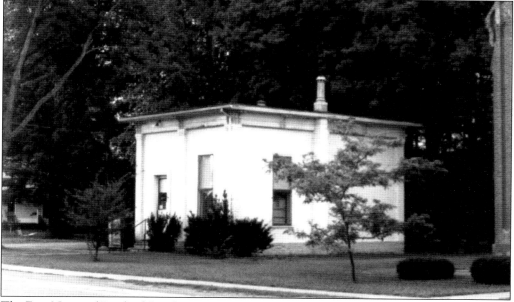

The First National Bank of Candor incorporated on March 3, 1864. The officers were Norman L. Carpenter, president; Jerome Thompson, vice president; and J. J. Bush, cashier. Carpenter died the following year, and Edwin A. Booth became president. The bank was robbed in 1868, and the money and banknotes were never recovered. In 1960, Farmer's and Merchants Bank of Spencer (now Tioga State Bank) purchased the bank. Today the building serves as the village municipal building.

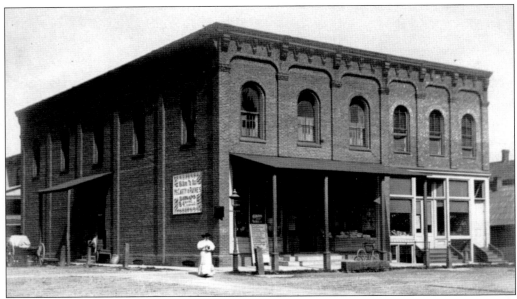

Jerome Thompson came to Candor in 1851 and joined his brother-in-law in the mercantile business on the corner of Mill Street and Spencer Avenue. The original wooden building burned and a new one was constructed in 1874 with brick from the Candor Brick Company. It remained a general store for over 100 years. Today it is an apartment complex. (Courtesy of Thomas McEnteer.)

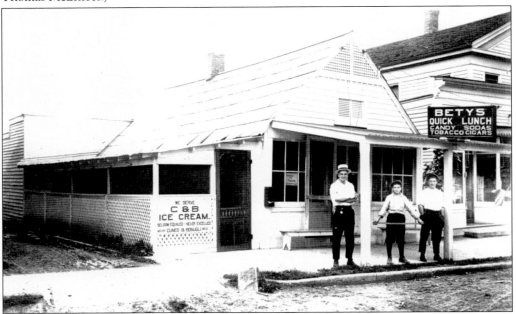

Around 1918, J. Betikaufer's Ice Cream Parlor was located next to Betty's Quick Lunch on Mill Street. In 1905, Merritt W. Van de Bogart ran a meat market here before purchasing McCarty and Payne's store. Herman Brink bought Betikaufer's old store. Later John Marks ran a barbershop and insurance business here for over 40 years. Eventually the building was torn down to make way for the Candor Fire Company garage in the 1950s.

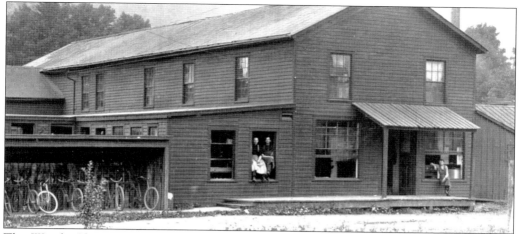

The Wands Glove Company on Factory Street (now McCarty Street), just off Mill Street, was incorporated in 1895. During World War I and World War II, the factory boomed, and at its height of productivity, the company employed up to 225 workers with a two-shift-per-day operation. In 1923, Edward Wands withdrew from the glove company, and the new owners changed the name to the Candor Glove Company with Willson S. Moore as president. When Moore died in 1957, there were only 10 employees. As there were no buyers for the business, and the demand for gloves had dwindled after the war, the business ended. The building was torn down in the 1960s. Below, Candor Glove Company employees are photographed in 1910 with Wands in the center in the derby hat next to the pole.

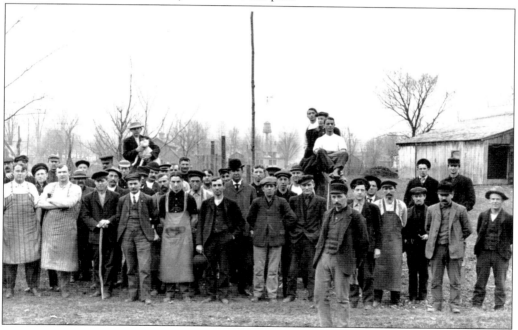

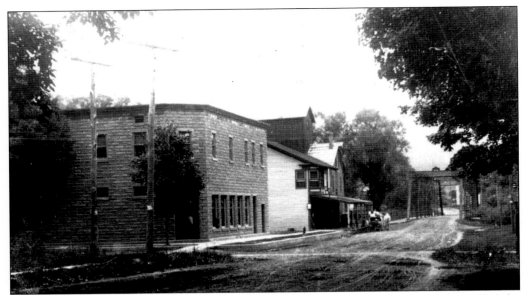

Built in 1906 as a general store by Almerion Johnson, this establishment was once called the White Elephant. In the 1940s, Lloyd Kirk bought it and converted it into Kirk's Rendezvous Grill. During the late 1900s, it was one of two popular bars in Candor. The old gristmill on the right was built in 1834 by Jesse and Ogden Smith. It was torn down in 1983 when a new bridge was built.

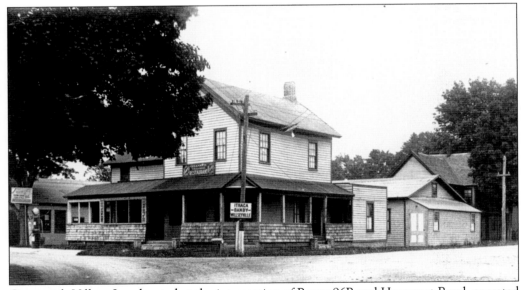

Greenwich Village Inn, located at the intersection of Route 96B and Honeypot Road, operated a gas station, a restaurant, and a dance hall. In the 1950s, Leo Yeier ran a plumbing and heating business, while his wife, Eudora, operated a sewing machine business. Eudora was the first woman elected town clerk in Candor. Their son Donald started the Vernonscope Company, which is housed next door. (Courtesy of Thomas McEnteer.)

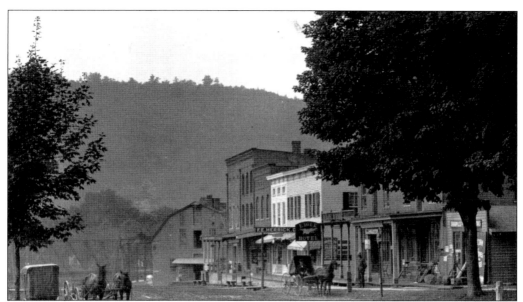

Candor Corners, located at the lower end of the village, was a separate, thriving community. From Sackett's Mill in the background to the Eagle Hotel, this area included a grocery store, undertaking and furniture store, and a druggist. In 1914, the hotel and hardware store burned, and in 1924, three other buildings were also destroyed by fire. Taken around 1908, the photograph below shows a different view, including signage on the building where Clarence Childs had his home and picture studio. The first floor was used for retail businesses for over 75 years. One was run by Clifton "Robbie" Robinson later by his son Paul "Johnny" Robinson. The upstairs rooms were used by the Independent Order of Odd Fellows and Rebecca lodges and later converted into apartments.

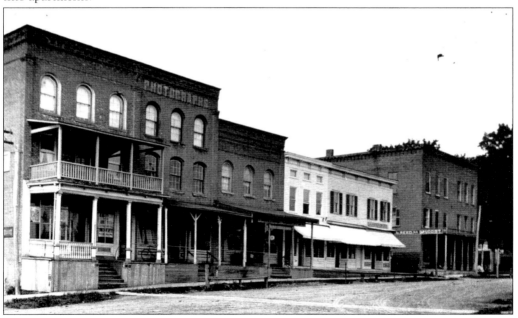

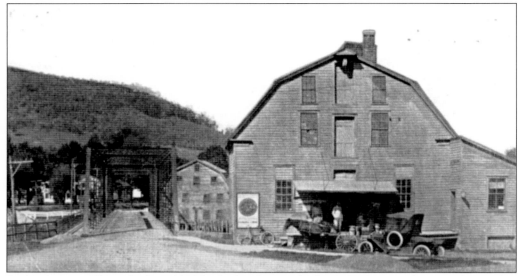

Sackett's gristmill was built in 1832 by Richard H. and John J. Sackett on the site of an earlier mill. In 1893, Nathan H. Ellis and Willson S. Moore purchased the property. The mill changed hands several times until 1925, when C. Paul Ward purchased the interest of Theodore Holmes. The following year, Haight and Ward adopted the trademark York State Buckwheat Flour and started shipping their product across the country. In 1929, the new owners were Ward and Van Scoy. The vacant mill was taken down in 1986. In 1908, the Candor Woolen Mill was located across the bridge behind Sackett's Mill (pictured below), and behind that was the blanket factory. For a short time around 1922, shoes were manufactured here until a fire destroyed all but the brick powerhouse. After that, it served as the public service garage.

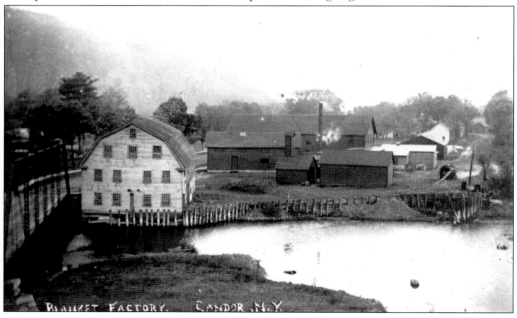

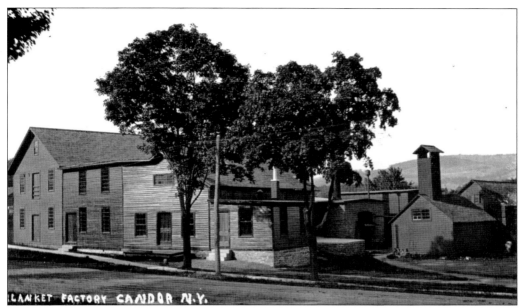

BLANKET FACTORY CANDOR N.Y.

In 1881, Charles F. Barager built a new mill and began the manufacture of horse blankets in the village. By 1886, the blanket factory was employing 50 hands and was turning out some 50,000 blankets per year. After Barager's death, the business was sold to George H. Hart and John P. Fiebig, who made ironclad blankets. Decline of the industry came when the automobile's popularity increased, and the demand for horse blankets dwindled. Fiebig and Hart sold to Peter M. Fowler in 1916. Later Theodore Austere, Frederick Condone, and Charles Witherell of Binghamton purchased the factory and converted it into the Candor Shoe Factory. Later that year, the shoe company went bankrupt. On July 19, 1926, fire destroyed the building. At right, Fred Lisk (left), Fred Wheeler (center), and a coworker enjoy a pipe break at the Candor Blanket Factory around 1906.

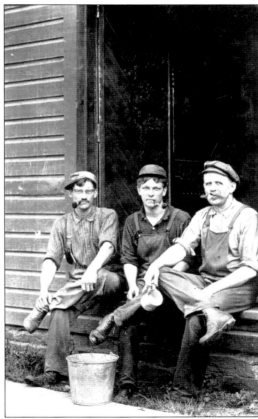

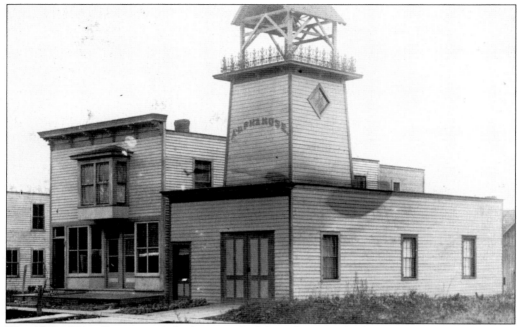

The Alpha Hose Company at the lower end of the village was built in 1903. It was originally a one-story firehouse with a bell tower, which was actually a windmill tower (above). Later when the Alpha Hose Company merged with the Alert Hose Company from the upper end of town in the 1950s, another floor was added to this building, and it became an apartment complex. The building on the left is the Grange hall, organized in 1874 as Grange No. 203, which became dormant for a time and then reorganized in 1907 as Grange No. 1111. Again the organization became dormant and was reorganized for the third time in 1920 as Grange No. 1466. The grange is semiactive today. Pictured below are members of the Alpha Hose Company lined up next to the fire station around 1910. (Below, courtesy of Thomas McEnteer.)

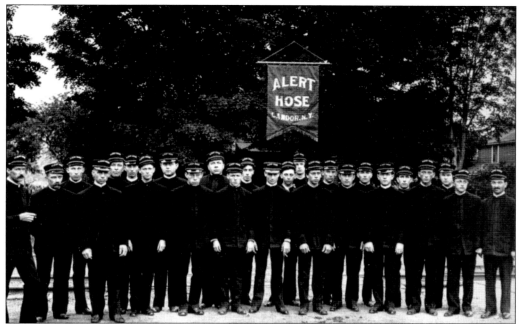

Not to be outdone, the Alert Hose Company formed and was located at 7 Mill Street at Candor Center. In 1900, Candor Corners and Candor Center merged to become the village of Candor, and in 1904, Hose Company No. 2 renamed themselves the Alert Hose Company. For over 50 years, the two fire companies took part in a rivalry that included many competitions at local events, like baseball games, until they merged in 1958. The Mill Street station became the central station until 1990, when funding for a new facility was obtained and the site moved to Route 96B. Pictured below is the hose cart that the Alert Hose Company bought; it was on loan to them from Ithaca Hose No. 1 from Ithaca.

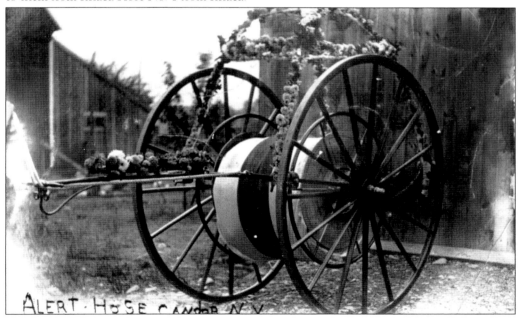

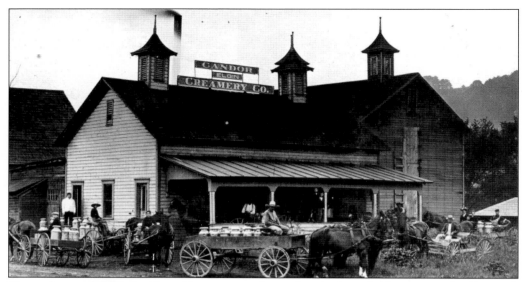

Pictured around 1902, the Elgen Creamery was located at the lower bridge next to the Catatonk Creek and the Delaware, Lackawanna and Western Railroad tracks that ran through the village. The creamery was built in 1898. In 1911, it was sold to the Alexander Campbell Milk Company and in 1916 was replaced with a milk plant that was later sold to Borden's. It was later purchased and turned into a repair shop for heavy mechanical equipment. H. Peabody Harness Shop (below) was once located here. The Delaware, Lackawanna and Western Railroad bridge can be seen in the background.

Willseyville, a small community in the town of Candor, was one of the outposts along the Delaware, Lackawanna and Western Railroad that came through Candor between Ithaca and Owego. It was an active community, and Fred C. Mix had a store on the corner of Main Street and Willseyville Square for many years. Next door was a blacksmith shop, owned and operated by Harry G. Mix. Harry was the son of Emery C. Mix, who ran the hotel across the street. Neither the blacksmith shop nor the store is still standing. (Courtesy of Georgia Westgate.)

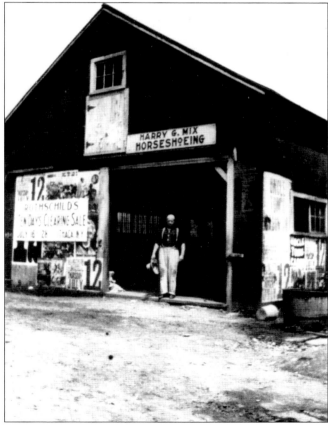

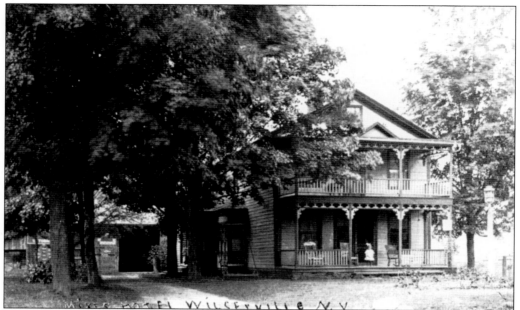

The Mix Hotel in Willseyville, pictured above around 1914, was owned by Emery C. Mix, who was also the justice of the peace in Willseyville for a number of years. His wife, Georgia Ella Mix, ran the hotel, which serviced the incoming passengers riding the train between Ithaca and Owego. Little Dorothy Mix is standing on the front porch. The hotel has been a home for many years now. (Courtesy of Georgia Westgate.)

Willseyville was a growing community in the early days of settlement. Several early grocery stores, like Strong's (pictured), came and went along Main Street. Like other communities that had a post office, Willseyville's post office has had many homes. For a time, it was located in Strong's store. (Courtesy of Thomas McEnteer.)

In 1886, the White Brothers Chair Factory in Willseyville was established for the manufacture of White's patent bent chairs and folding tables. The factory was three stories high and was operated by a 60-horsepower steam engine. Some 30,000 chairs and 10,000 tables were turned out each year. Asa Frank White and Edward M. White ran the factory, and Charles O. White was the traveling salesman. (Courtesy of Howard Weber.)

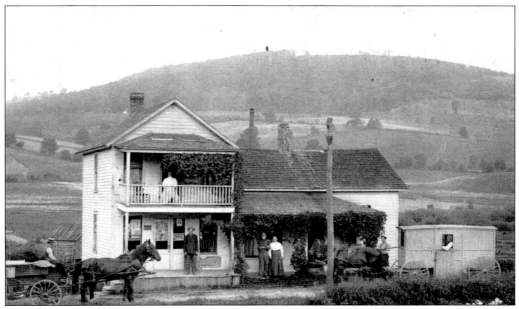

Tucker's Store was located on Prospect Valley Road between Willseyville and Candor Village. The wagon pictured belonged to F. P. Tucker. Across from this store was another shop owned by Ike Whitley. The store above remained in business until after Tucker's death. At one time, the store sported a gas station. Both buildings are now gone.

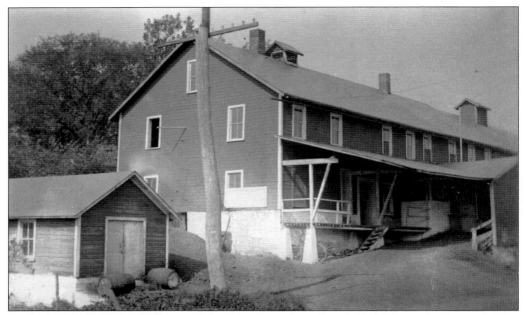

Borden's Milk Company built several facilities along the railroads like this one in Catatonk. The creameries were located close to the creeks where ice could be harvested and kept in icehouses for use in the summer months to keep the milk cold and ready for transport.

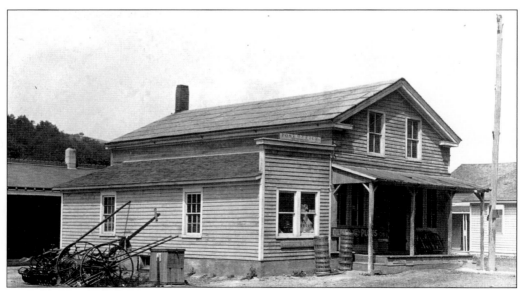

Christian's Store in Catatonk sold dry goods and plows to the farmers. This store also served as a local post office for the community. In the early 1900s, town and county tax collections were made here as well as at Strong's Store in Willseyville and George Smullen's store in Weltonville. (Courtesy of Thomas McEnteer.)

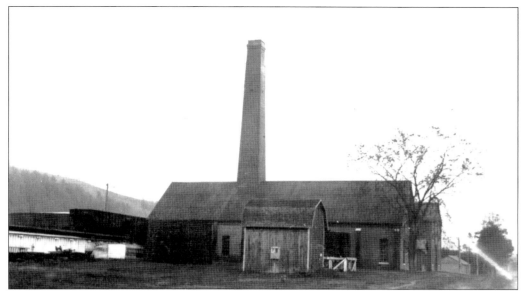

In 1881, the Standard Oil Company constructed a petroleum oil pipeline pumping station in Catatonk and other stations between Olean, New York, and Bayonne, New Jersey. It consisted of a storage tank and a large brick boiler house complete with a 115-foot smokestack. There was a large pumping house and a smaller office building. In 1920, it was sold to Columbia Gas and Electric Corporation for distribution of natural gas. A year later, Tioga County purchased the pumping station, and it is now being used as the county highway department. On October 12, 1920, this huge holding tank (below) burst into flames that shot 75 feet into the air, and the smoke could be seen for miles. The fire took over 12 hours to stop with approximately 9,000 barrels of oil having burned. The loss at that time was estimated at $45,000. (Courtesy of Thomas McEnteer.)

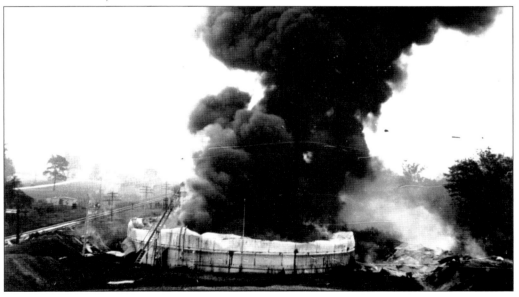

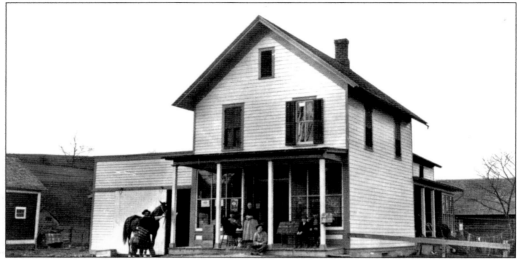

Weltonville is located in the southeastern corner of the town of Candor. A rural farming community, Weltonville's businesses were few. In 1900, George Smullen ran a store at the lower end of Upper Fairfield Road. Over the years, it has had several owners, including Richard Barnum and Kenneth Mead. Today the building is used as a garage. (Courtesy of Thomas McEnteer.)

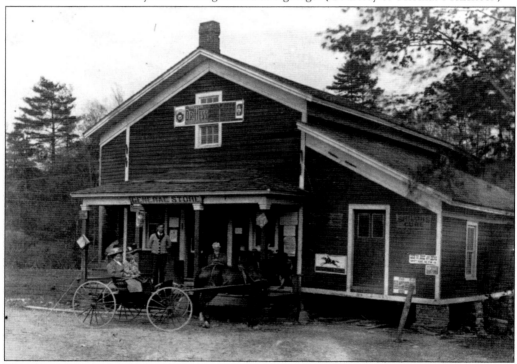

Thomas and Myra Duff owned the general store pictured above at Strait's Corners in the early 1900s. Seated on the bench are Ivan Cook, Harold Cook, and Mabel Duff. One of the Sarson girls in the buggy is holding three-year-old Kenneth Duff. Elias Van Luven sits behind the horses, while Thomas stands. Used as an apartment building for a time, it is once again a general store. (Courtesy of Milton and Patricia Dougherty.)

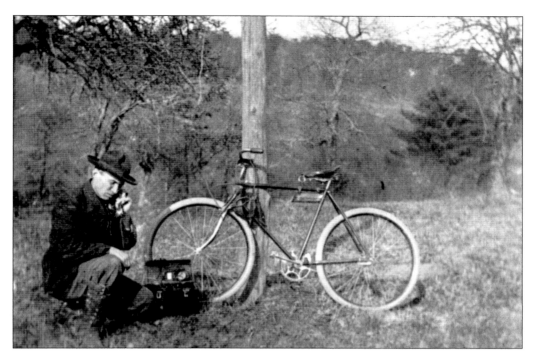

Preston C. Meddaugh, with help from others, built a telephone line from his Upper Fairfield farm to the village of Candor and hooked up a dozen phones. Frank Meddaugh (above) worked as the lineman for the Candor Telephone Company, riding his bike to check out and repair telephone lines. At right, Hester and Jess Hover worked the telephone switchboard on Main Street in the village during the 1920s and 1930s.

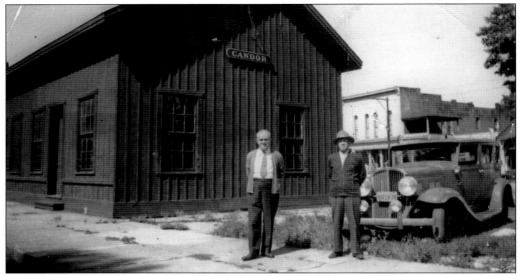

In 1949, conductor Kenneth Smith and station agent Abe Jackson (above) stand outside the Candor Delaware, Lackawanna and Western Railroad depot on Main Street. Passenger service dwindled, and it was not long after this photograph was taken that the last train went through town and the tracks taken up in the late 1950s. Taken in 1906, the picture below shows the front side of the Delaware, Lackawanna and Western Railroad station. Goods are lined up on the platform ready for shipping. In 1962, the Farmers and Merchants Bank of Spencer, located on the corner of Bank and Main Streets in Candor, traded sites with the depot and proceeded to raze the station in order to built its new bank.

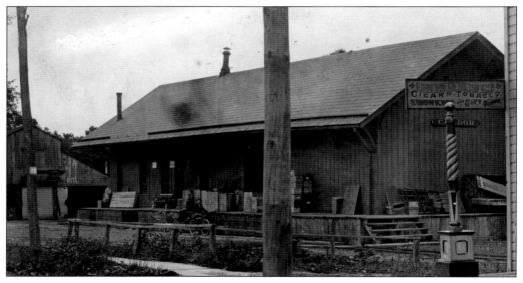

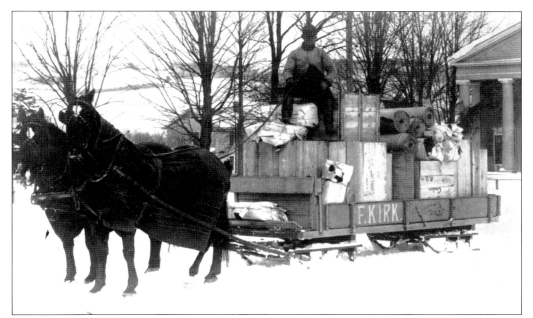

Freemont Kirk was known for his draying business. He met the train that was full of goods, and once everything was loaded onto his wagon, he went about town delivering them to the various businesses.

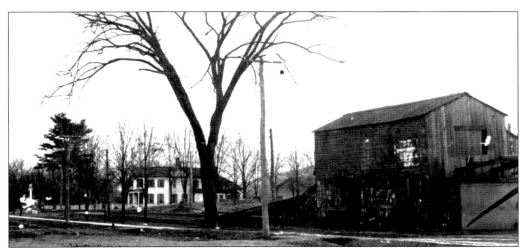

In 1907, Frank L. Heath built a larger, new coal shed that replaced the one pictured above. Mildred D. Heath purchased the interest of Delbert G. LaGrange in her husband's coal business and became Candor's first major businesswoman. She sold the business to Clifford Hull in 1943, and it became the Candor Coal Company. Over the ensuing years, the property changed hands and businesses several times. Today it remains empty.

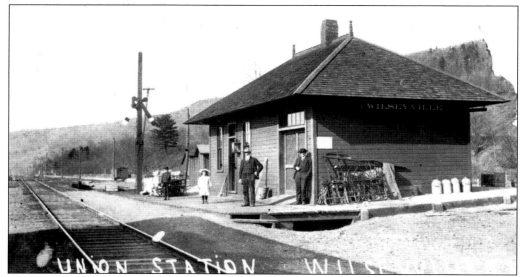

The Willseyville Union Station, pictured above in 1909, serviced the Delaware, Lackawanna and Western Railroad and the Elmira, Cortland and Northern Railroad (a branch of the Lehigh Valley Railroad, which discontinued service in 1935). The second set of tracks ran behind the depot. The Elmira, Cortland and Northern Railroad also had stations at Snyder Station and West Candor before winding its way into Spencer. The Willseyville track crew (below) is ready to go out and inspect the rails. In the background is the old Willseyville creamery. (Below, courtesy of Thomas McEnteer.)

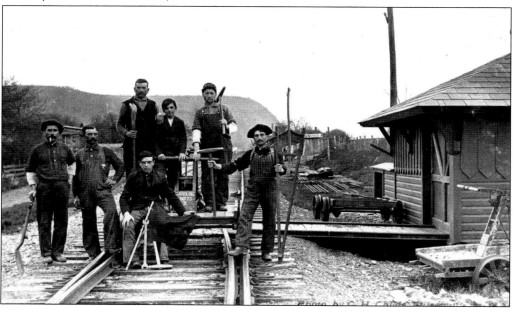

Two

A COUNTRY EDUCATION

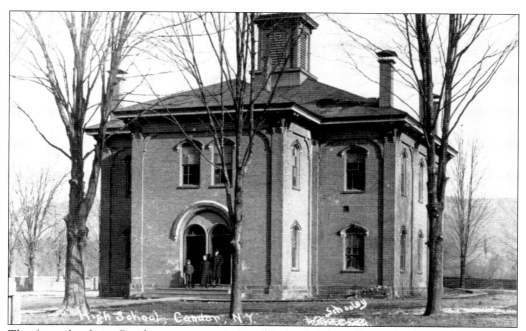

The first schools in Candor were commissioned in 1813. The village school was designated as District No. 9, but it was not until 1864 that the Candor Free Academy (pictured) was established under the Union Free School law through the efforts of town supervisor J. W. Thompson and Dr. John C. Dixon. Rural schools were scattered across Candor's hillsides until centralization in 1938.

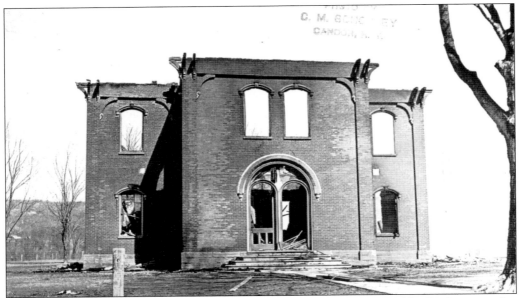

On March 30, 1909, the Candor Free Academy, built in 1868, was gutted by fire late at night. The Alpha and Alert Hose Companies both came on the scene, but there was no water coming from the hydrant for about 30 minutes due to icy slush in the main line. The firemen found a set of footprints in the snow that led to and from one of the windows. After the fire was extinguished, they determined that the fire had been started in an upstairs closet. This, coupled with the fact that the school bell was stolen, made them suspect that the fire had been started intentionally. To this day it has remained a mystery as to what actually happened to the bell and who started the fire.

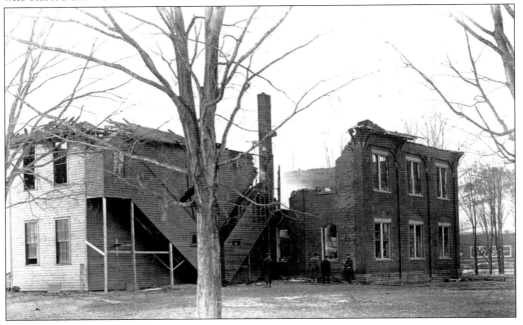

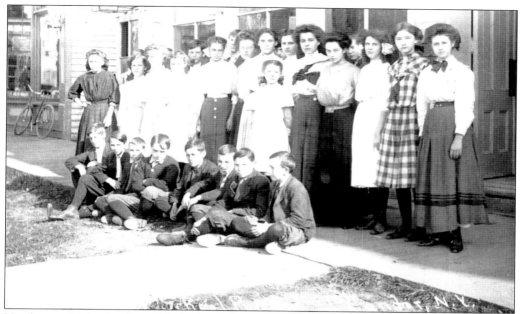

Until a new high school could be built, students were relocated to the town hall (above) or to the Barager house on Water Street. Unused seats from Owego Free Academy were installed at these locations to accommodate the students. Below, high school students in grades 9 through 12 who were displaced by the fire line up in front of the Delaware, Lackawanna and Western Railroad station across from the town hall on Main Street for a photo opportunity.

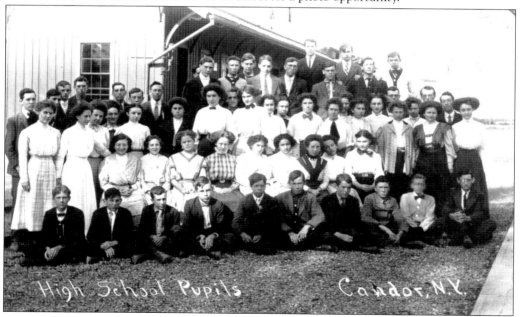

High School Pupils Candor, N.Y.

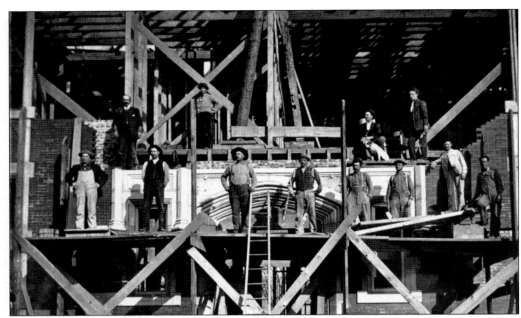

Between 1909 and 1910, the new high school was under construction by Owego contractor Martin Bauer. The cost of the structure (below) was $22,350. The picture above shows the workmen on scaffolding above the main entrance, which is still part of the current high school. Today the main entrance has been redone, but the archway is still evident. On April 29, 1910, the new school was open to the public with a ceremony that had the assembly room overflowing. The new building could accommodate 250 students with room for growth. Over the ensuing years, the school has gone through many building additions and renovations, all of which have been constructed around the original structure that was built in 1910. (Above, courtesy of Thomas McEnteer.)

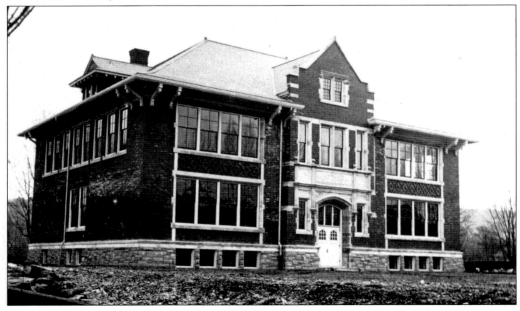

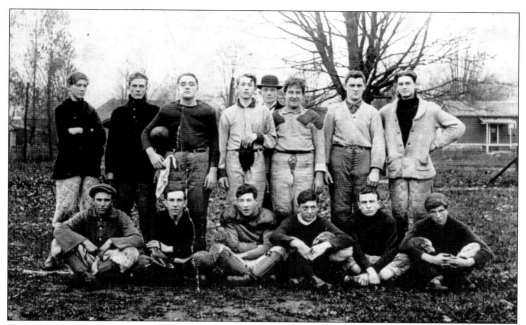

Pictured in 1913, the Candor High School football team includes (first row) Harold Hull, Norman Hollenbeck, Robert Betikaufer, Oreland Jennings, and Ralph Mengies; (second row) Arthur Beebe, Lloyd Van Ostrand, Ralph Wheeler, John Craig, Nathan Turk, Samuel Blinn, Lee Dorn, and Earl Van Etten.

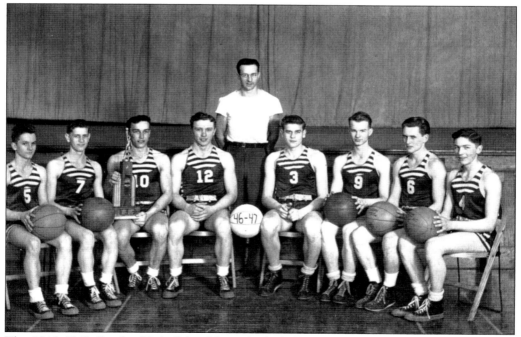

The 1946–1947 Candor High School boys' basketball team members, from left to right, are Windell Richards, Charles Andrews, Ed Osovski, Ed Winnick, Henry Vatter (coach), Marvin Kilpatrick, Peter Ward, Norman Sullivan, and Jack Williams.

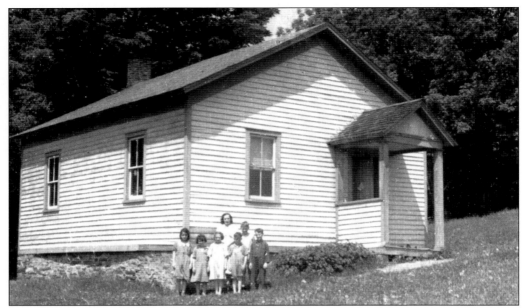

Prior to centralization in 1938, the town of Candor had over 20 school districts scattered around the countryside. District No. 21, was located on Dry Brook Road about a half a mile south of Stevens Road on the left. In 1936, prior to the school's closing, Ruby Davis was contracted to teach here. The schoolhouse was sold as a residence, remodeled, and remains a home today.

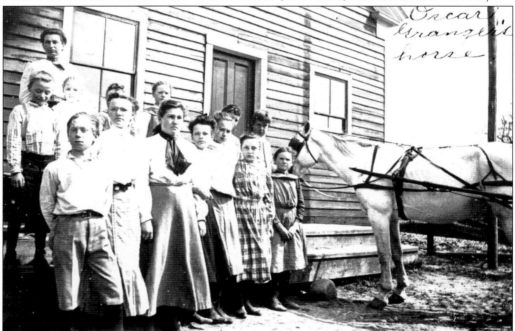

Gridleyville Rural District School No. 3 is now a home and is located on the east side of Gridleyville Crossing Road just north of Dry Brook Road. Mildred Searles was the teacher in 1936. In the picture, Oscar Granger's horse is hitched to the stair railing. Today this once dirt path between Routes 96 (to Spencer) and 96B (Owego to Ithaca) is now paved, making it a busy crossroad.

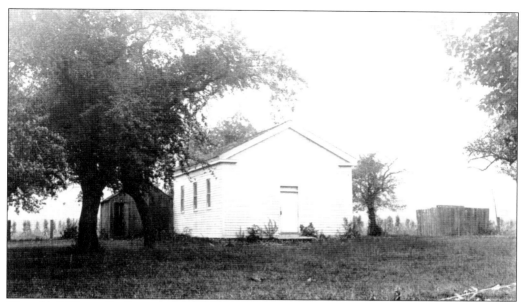

The old Willseyville District School No. 6 was built in 1817 at the crest of the hill directly across the road from the Coddington Road. A windmill pump was built to provide water for the students. From October to June 1892, Frances S. Eastman was the teacher. The average attendance was 25. There were 43 eligible students in the area at that time. In 1918, a new schoolhouse was built after a fire leveled the old school. The new school (below) was located in the center of Willseyville. Lillian Niles and Erma Huslander were the teachers prior to centralization in 1938. Besides being a schoolhouse, it also housed the Willseyville Post Office. In the late 1950s, it opened again to accommodate overcrowding from the central school until a new elementary building could be built. Later a group of people joined together to purchase the building and turned it into a community center. It is now a home.

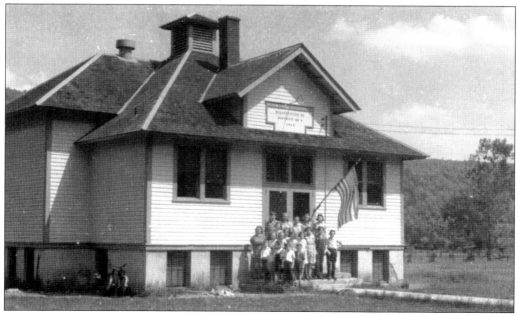

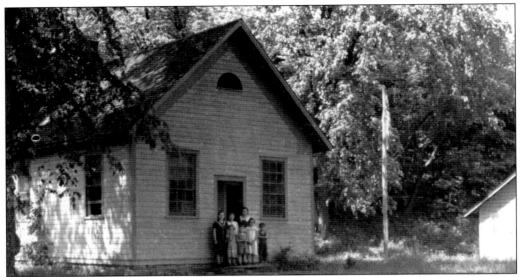

District School No. 20 was located at Upper Prospect Valley on Bush Road. Jacob Willsey's diary states that he built the school in September 1851. Frieda Ferguson was the teacher contracted in 1936. Kate Dykeman also taught here. Pictured below, from left to right, are Terry Russell, Vernice Quick, Frances Quick, Kate Dykeman (teacher), Ina Rice, Leaffie Rice, Frankie Russell, Florence Quick, Charlie Hurd, and Maurice Lee. The schoolhouse was moved from this location and remodeled into a home.

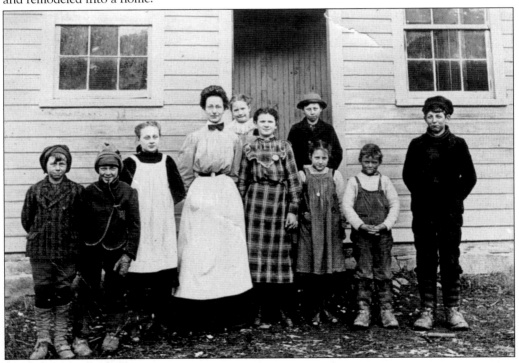

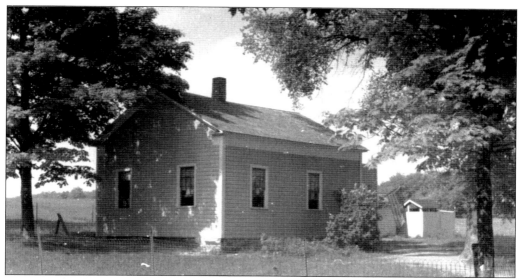

District School No. 7 was located at Upper Fairfield on the intersection of Barden and Lathrop Roads. In 1892, of the 38 eligible students who could go to school that year, only 29 attended part of the time; the average was 16 students. Lillian Jennings taught from October to February, and Grace Tucker taught from March to July. In 1936, Florence Brucknak was the teacher. After centralization, the building became a community center for a short time. Today it is still standing but remains vacant. Pictured below are the students who attended here in 1911. From left to right are Isabel Galloway, Beatrice Legge, Rhoda Tubbs, Leon Turner, Edna Turner, George Clark, James Borden, Clara G. Howard (teacher), Edna Brown, Norman Brown, Winifred Strong, Isa Howard, and Mildred Leet.

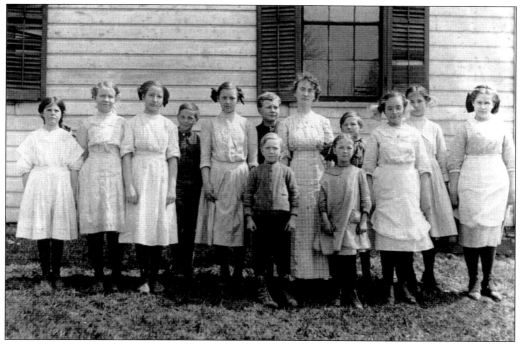

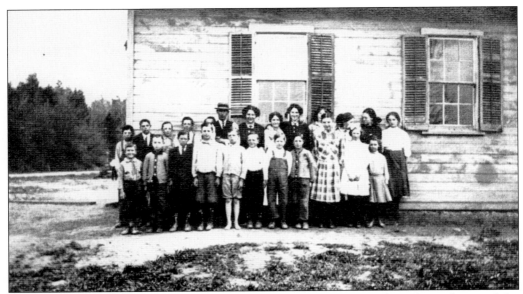

Strait's Corners School was designated as District School No. 12 and was located west of the intersection of Strait's Corners Road and Terwilliger Road. Children from the town of Tioga and the town of Candor attended here. In 1892, 42 students were registered. Here Myra Duff poses with her class in 1910. Elizabeth Ott was contracted to teach in 1936. (Courtesy of Milton and Patricia Dougherty.)

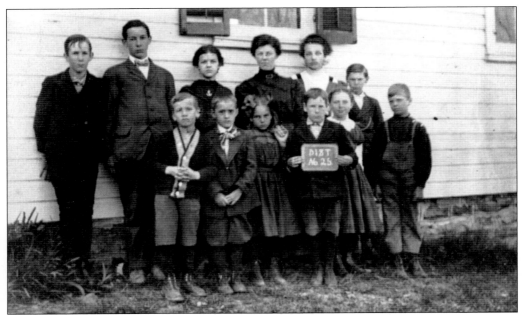

Cranes Nest, District School No. 25, was also known as Brink School in 1922 and was located on the corner of Howard Hill and Crane's Nest Roads. From left to right, students who attend school here in 1910 are (first row) Merrill Howard, George la Son, Ruth Brink, Edgar Bangs, Nina Hoyt, and Clarence Allen; (second row) Henry Bangs, Walter Bangs, Hazel Andrews, Pearl Andrews (teacher), Bertha Howard, and Clifford Brink.

Three

RELIGIOUS DIVERSITY

The early pioneers of Candor were filled with a great religious fervor and felt that the underlying principle of real success lay in close alliance to the religion of their fathers. Centuries later, Candor's religious diversity still abounds. Candor was given the designation of "Saint's Rest" due to the number of preachers who settled here for the sunset of their lives.

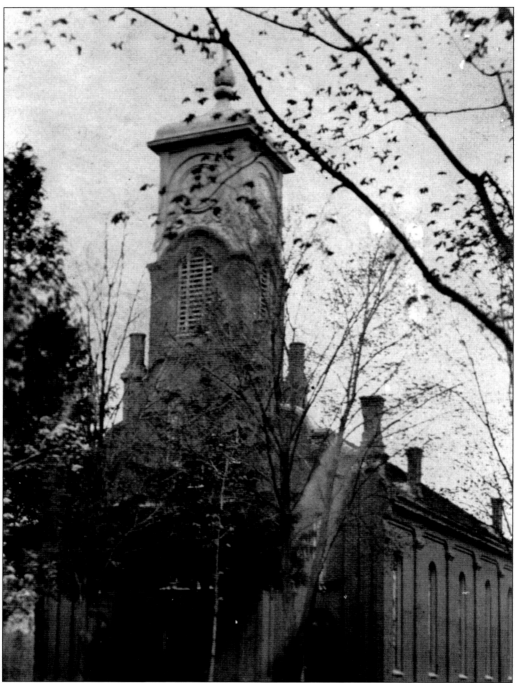

Early religious settlers met in Sylvester Woodford's barn and in Abel Hart's weave house to practice their beliefs. In 1808, they formed the Farmington Society in honor of Farmington, Connecticut, where they had lived before coming to Candor. They continued to meet in several locations until 1867, when the Kinney family, of Kinney Shoe Company fame, donated land on which to build their Congregational church (pictured).

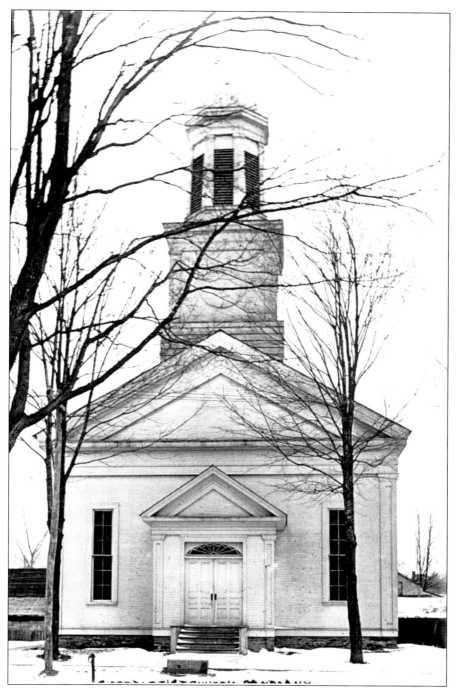

Allen Memorial Baptist Church is pictured above around 1900. A meeting of the area's Baptist churches met at Hiram Allen's home in 1852 to form the Candor Village Baptist Church. The above house of worship was built in 1855 at a cost of $5,000. From these humble beginnings, the church has grown over the years and now includes Sunday school classrooms, a gymnasium, and meeting rooms.

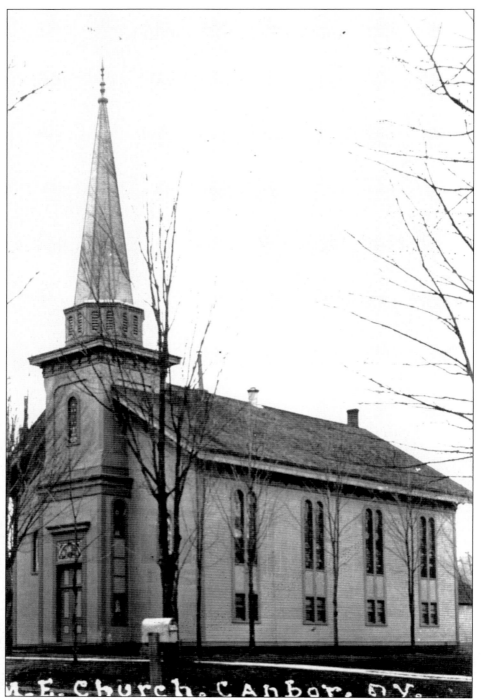

M.E. Church. Canton, N.Y.

After holding religious services at Jared Smith's home for a number of years, a Methodist Episcopal Church was organized in 1827. The first church was built on land given by Daniel Hart. The present McKendree United Methodist Church, pictured above in 1907, was constructed in 1865 by A. F. Stowell, a local contractor who also built the Congregational church.

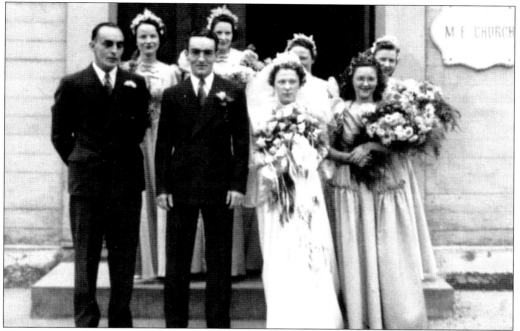

The 1941 Heath wedding (pictured) was held at the McKendree United Methodist Church. Pictured from left to right are (first row) Earl DePuy (best man), Glenn DePuy (groom), Dorothy Heath DePuy (bride), and Emily Bostwick Kane (maid of honor); (second row) Elizabeth DePuy, Julia Ott, Frances Furman, and Betty Harsh. The DePuy's owned the IGA grocery store and the Heath's had the coal business. (Courtesy of Sandra DePuy Brown.)

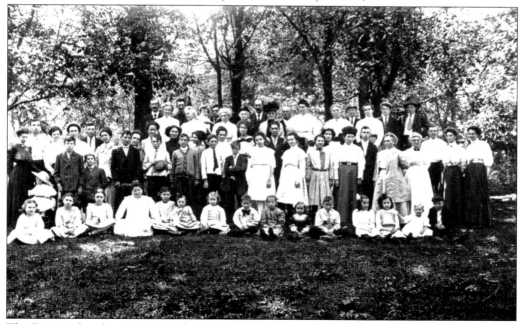

The Baptist church picnic took place at Selah Hart's grove near Maple Grove Cemetery in 1912 not far from the original Hart homestead.

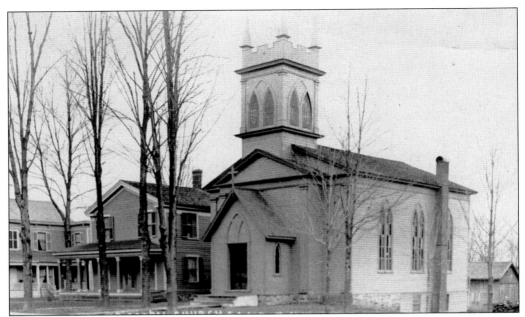

St. Mark's Episcopal Church was organized April 23, 1832, with Rev. Lucius Carter as the rector. The wardens were Seth and William Bacon, and the vestryman was Daniel Bacon. It was not until 1835 that the society purchased the lot it now occupies on lower Main Street from Richard H. Sackett for $75. Two years later, the edifice was erected. The cost of the church was $5,000.

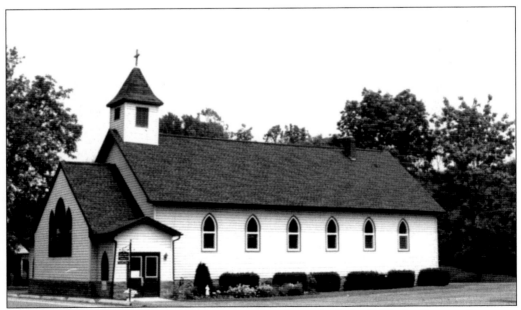

Although the St. Francis of Assisi Catholic Church was built in 1930, the first services were held at the home of William Kehoe of Candor as far back as 1870. He had a permanent altar built in his home. Between 1917 and 1925, those of Polish descent meeting in Catatonk decided to build a church. The construction was undertaken by Victor Kaczanorski, Mike Nagel, and John Winnick.

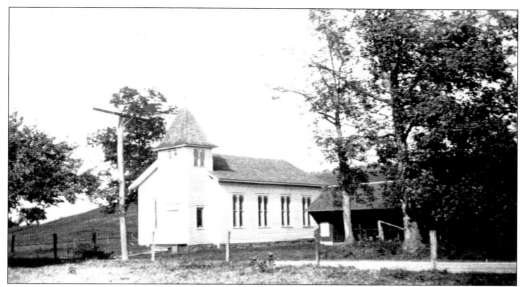

The Catatonk Baptist Church was established in 1861 as the Union Church of Catatonk. Later it was a Methodist church until 1852 when the Methodist circuit dropped it according to the Wyoming conference. However, it became the Union Church of Catatonk again in 1906 and in 1909 was again listed as the Methodist Church of Catatonk. Before long, it became a Baptist church, which it remains today.

In June 1917, several people of the Seventh-day Adventist religion met at the home of the Belknap family in Campville to establish a church in Tioga County. A host of people transferred their membership from other churches, constituting the membership of the newly organized Seventh-day Adventist Church in Catatonk. They bought an old schoolhouse (the center section of the building shown above) and after several additions turned it into a thriving meeting place.

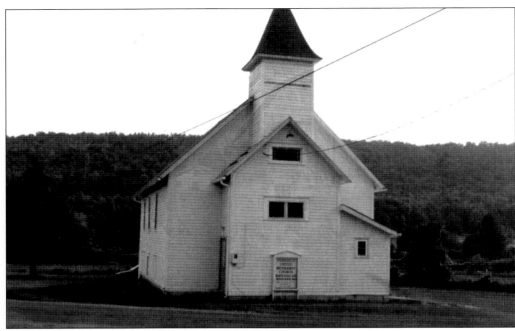

The Lower Fairfield Baptist Church was built in 1871, with its members withdrawing from the Mother Church on West Owego Creek Road. In 1900, it became incorporated as the Methodist Episcopal Church of Lower Fairfield. Alfred Dennis and his wife, Mary, deeded the society half an acre of land as a gift. The church (above) cost $2,000 to build and was dedicated on April 5, 1901. It is still a functioning church. Upper Fairfield Union Church's society was organized at the home of Jacob Clark. In 1852, the society incorporated as the Trustees of the Fairfield Methodist Episcopal Church. The church pictured below was built in 1858 by a group of local farmers of different Protestant persuasions and became a place of worship for the Methodists, Christians, and Baptists. The church is no longer standing.

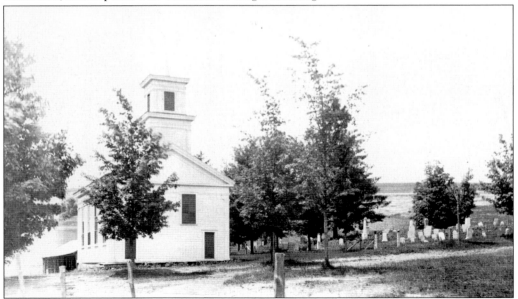

Strait's Corner Baptist Church (above), also known as the Baptist Church of Pipe Creek, was organized in 1842 with 38 members. The name changed in 1887 to Strait's Corners Baptist Church. The first pastor was Elder Dearborn. Strait's Corners takes its name from David Strait, an early settler. Below, the Strait's Corners Baptist Church Ladies Aid Society in the 1930s consisted of, from left to right, Ella Kuhns, Ima Gowan, Clara Dougherty, Helen Dougherty, Myra Duff, and Garnet Hollenbeck. (Above, courtesy of Milton and Patricia Dougherty; below, courtesy of Jean Dougherty.)

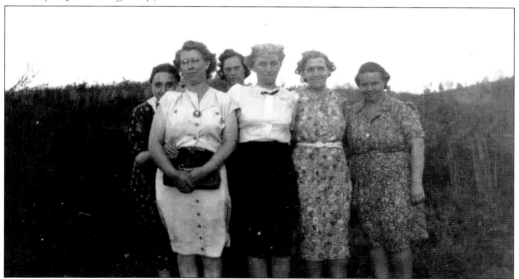

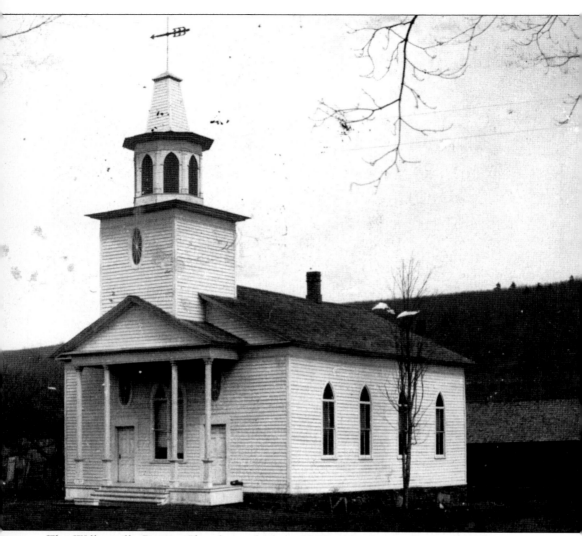

The Willseyville Baptist Church was built in 1840 on land given by Jacob Willsey. In 1876, the society became incorporated as the First Methodist Episcopal Church of Willseyville. The building was shared with the Methodists and the Swedenborgs (a spiritual cult of the time that eventually established their own church in Danby). In 1843, the meetinghouse fell under the organization of the Baptist churches in the area. In 1938, the church changed its name to the Community Baptist Church of Willseyville. (Courtesy of Thomas McEnteer.)

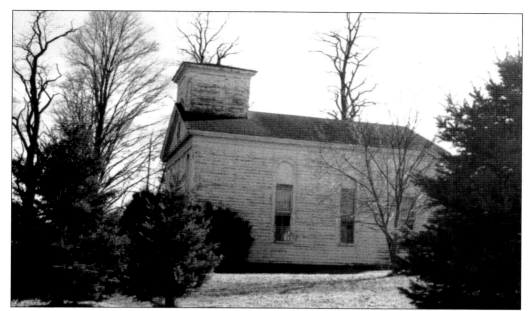

Pleasant Valley Methodist Church was built in 1844 and is located in Weltonville on land donated by Abram Blackman and William Lawrence. At times, the church was referred to as the West Creek Church or Churches of Christ in Christian Union. The latter was a designation given in 1909 when a group of Christian churches with a Wesleyan Armenian doctrine banded together and had headquarters in Circleville, Ohio. The church recently went defunct.

Anderson Hill Church was organized in 1830 with David Darling as their leader. The society became incorporated as the Trustees of the Methodist Episcopal Church of Anderson Hill on January 30, 1860. At that time, Levi Andrews, Stephen Anderson, Theron D. Kyle, Augustus J. Eaton, and Charles C. Howard were the trustees. Anderson deeded the society one third of an acre of land. The church is no longer standing. (Courtesy of Thomas McEnteer.)

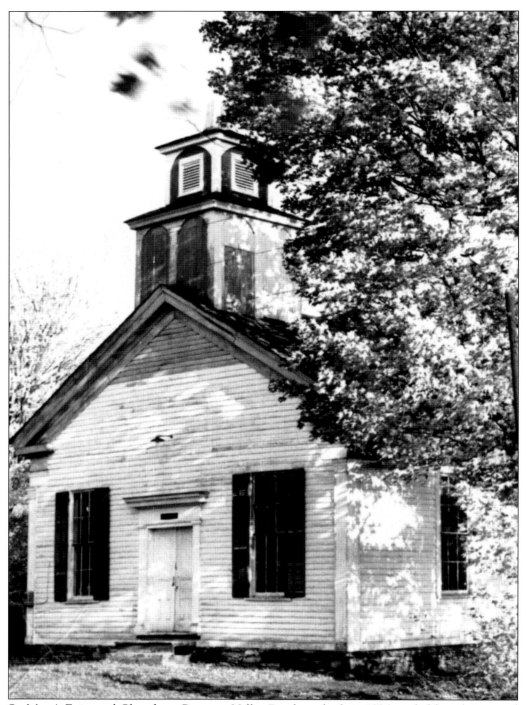

St. Mary's Episcopal Church on Prospect Valley Road was built in 1836, and although it served the surrounding community for many years, it finally tumbled down in the 1990s. The society originally met in the schoolhouse until 1886 when it became incorporated as the Prospect Valley Methodist Episcopal Church of Candor.

Four

A PLACE TO CALL HOME

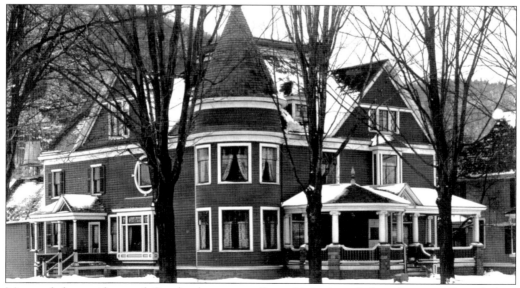

Many of the residents of Candor became well established, and their homes reflected their position in the community—some structures were rather grandeur, some were cozy, while others were basic, depending on the time they were built. These homes reflect something of Candor's history, like the Wands home located on Spencer Avenue (pictured). Edward Wands came to Candor and started the Wands Glove Factory in 1895 on Factory Street (now McCarty Street).

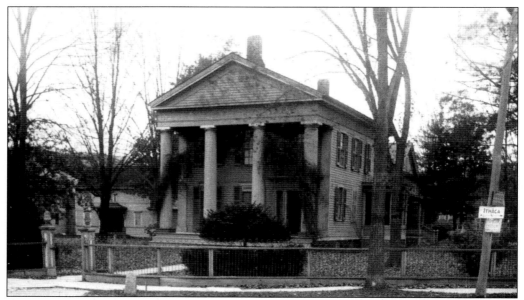

In 1884, the property on the corner of Bank, Mill, and Main Streets was deeded to Epenetus Howe, the first village president in 1900 when the village incorporated. He willed it to his daughter Nancy E. Bennett, and it stayed in the family until 1990. Today the carriage house and fence are gone, and instead of a home, it houses a veterinary clinic and a massage therapy and wellness center.

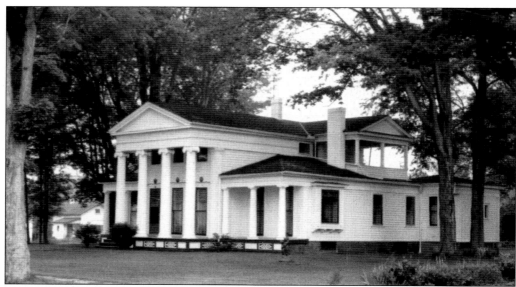

In 1848, John J. Sackett, owner of the gristmills and woolen mills in Candor, built the house pictured. It was remodeled in 1880 by Edwin and Mary Booth. Their daughter Mary A. Booth married John Fiebig. When John died in 1920, Robert Wells, president of the First National Bank, and his wife moved in with Mary. When Mary died in 1957, the Wellses inherited the house. The home has changed hands twice since then.

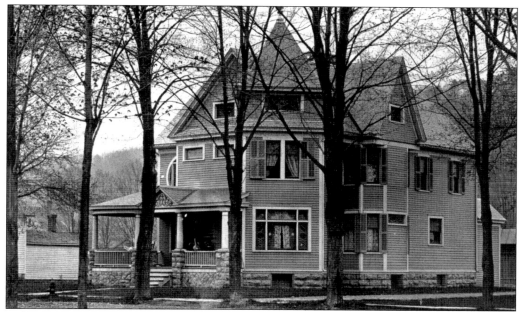

Willis G. Bostwick owned the home located at 99 Main Street (pictured). He owned and operated the Hay Barn, once called the Ward and Van Scoy feed mill and currently known as the Home Central business, at 7 Rich Street. The train tracks ran just behind the Hay Barn, making it easy to load farm produce, such as hay, potatoes, and grains.

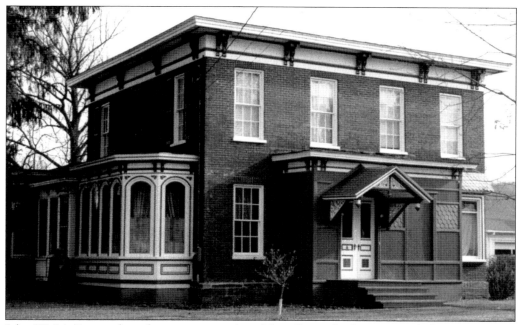

John W. McCarty, whose home is pictured on Main Street, had a mercantile business on the corner of Mill Street and Spencer Avenue as early as 1851. McCarty was also part owner of the Wands Glove Company. McCarty Street, where the glove factory operated, was named after him. In 1904, McCarty had a water fountain installed for horses next to his store.

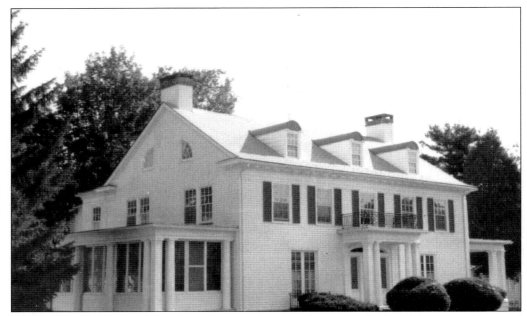

Originally a smaller and less imposing cottage, Dr. Amos Canfield of New York City had this house built as a summer home. It was extensively rebuilt in 1916 and was converted into apartments in the 1950s. Today Frank and Eva Mae Musgrave run it as the Edge of Thyme Bed and Breakfast.

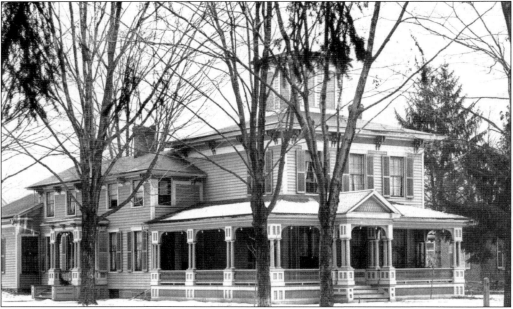

The Henry D. Heath home, also the Kinney home, home of the Kinney Shoe Company, was located on the corner of Main and Kinney Streets. For a time, the Spinning Wheel Diner operated at this location and took in boarders during the wintertime when students came to town from the country to attend school. Heath ran a hardware and farm implement store near the Candor depot further down Main Street.

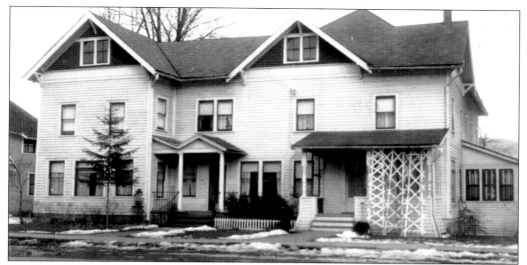

Charles Woolever of Van Etten bought the Hotel St. Clair from N. W. Griffin and ran it as the Woolever Hotel. The hotel was built as a home in 1870. In 1925, Myron Miller, owner of the furniture and undertaking business, bought the hotel and turned it into a home. Cloyd and Beverly Manzer purchased it and ran a funeral business there between 1969 and 1989. Today it is a home with a home-based business run by the Bergs.

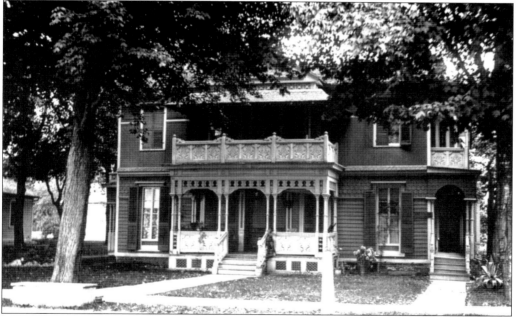

Dr. H. T. Dunbar was one of several doctors that practiced in Candor and lived on Owego Street in this home, pictured around 1909. The summer of 1913 was dry, and there was an outbreak of typhoid fever in the area. Dunbar encouraged everyone in the village to boil water before drinking it. There were no reports of anyone in the community who had contracted the disease.

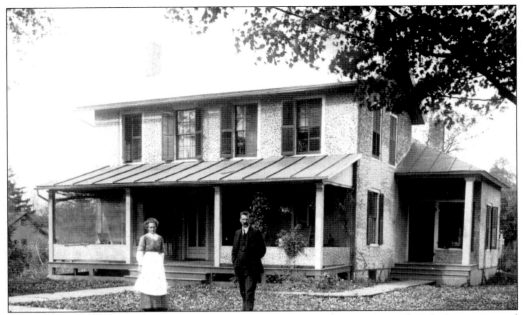

May and her husband, Will Beebe, stand in front of their home on 22 Church Street around 1914. Hiram A. Beebe and his son Will came to Candor from Brookfield in Madison County, and started the *Candor Courier* in 1899. Hiram was the publisher, and Will was the editor. Later Will became the president of the Alpha Hose Company when it formed in 1903; he was also town supervisor for a time.

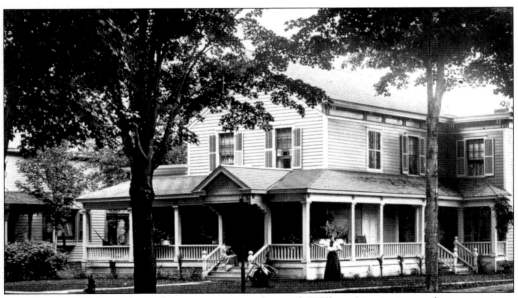

In 1878, James H. Jennings, a druggist in partnership with William Jennings, was the secretary on the board of education in Candor and lived in this home, pictured about 1906. The drugstore was next door to the Candor Hall at 85 Main Street. At one time, James was a town supervisor.

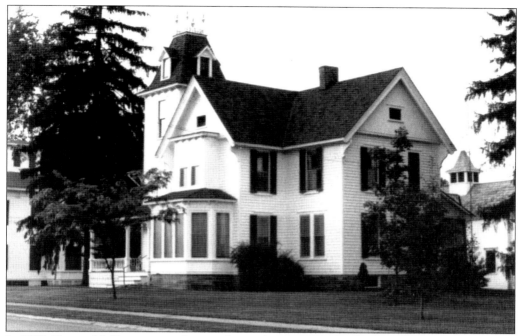

In 1878, George H. Hart was a cabinetmaker and proprietor of a plaster mill on Mill Street near the upper gristmill. He sold the mill to S. Egbert Gridley in 1885. In 1878, he had this house built, and until recent years, it was owned by a member of the Hart family. Hart served on the board of education and was village president.

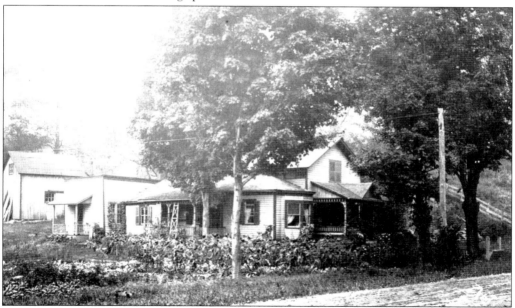

The Honorable Jacob Willsey moved to the Big Flatt from Fairfield in Herkimer County in 1815 and built this humble abode. The hamlet was later named Willseyville in his honor. His title came from his serving as justice of the peace. At one time, the house belonged to Harry Mix, whose blacksmith shop was located across the road. (Courtesy of Thomas McEnteer.)

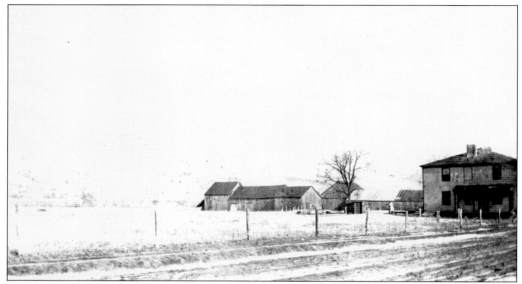

Capt. Abel Hart came to Candor in 1796. In 1808 and 1809, Hart built a larger house that is now owned by Masonic Lodge No. 411. Hart ran it as a halfway house and opened one of his sheds for women in the community to use as a weave house. In 1811, the first town meeting was held here, and in 1913, the meeting to organize the establishment of schools under the new state law took place here. (Courtesy of Howard Weber.)

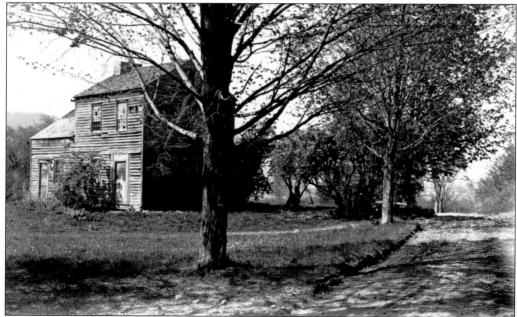

Russell Gridley bought 1,700 acres in the West Candor area and settled there in 1803. It was reported by circuit judge Lansing White in 1904 when he visited his fellow masons at the Gridley homestead (pictured) that this home, which is no longer standing, had Masonic symbols painted on the walls in an upper room where lodge meetings were held. (Courtesy of Howard Weber.)

Five

REFLECTIONS
OF PASTIMES

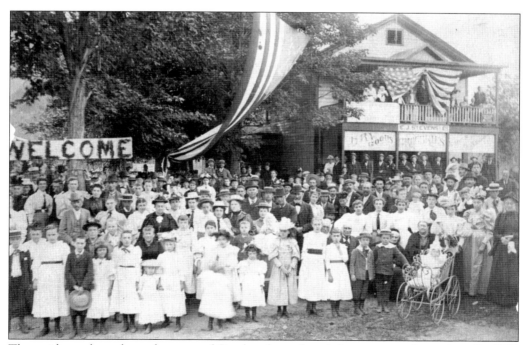

The residents throughout the town of Candor always found time to enjoy themselves. In 1895, Willseyville residents assemble before what then served as Edison J. Stevens's store to help celebrate a festive patriotic occasion.

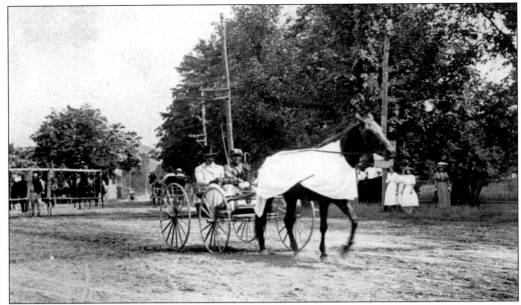

The 1912 annual Fourth of July parade came through the intersection of Mill Street, Main Street, and Spencer Avenue in front of Epenetus Howe's home (behind the trees on the right). In the background, the Wrong Brothers Flying Machine won that year's event for the most ingenious outfit. L. B. Griffin and Floyd Van Etten won cigars for their efforts. Candor has continuously held a Fourth of July celebration since 1889.

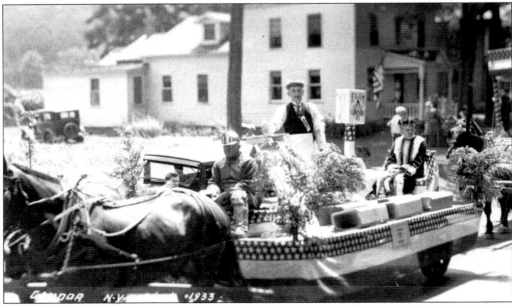

In 1933, the Candor Free and Accepted Masons of Candor Lodge No. 411 took part in the annual Fourth of July parade. Riding the float is Roy Coursen (driver), Will Badgley is sitting on the end, and Charlie Compton is standing. In the background is Eda Wentworth's home on Foundry Street. She was a local businesswoman who ran a milliner's shop in Candor. (Courtesy of James Roberts.)

Several bands came out to march down Candor's streets to help celebrate the Fourth of July. As word spread of Candor's popular event, people from surrounding towns and villages vied for space along the streets to watch the parade, and then they took part in and enjoyed the other events the town put together for this traditional celebration. The celebration continues to this day.

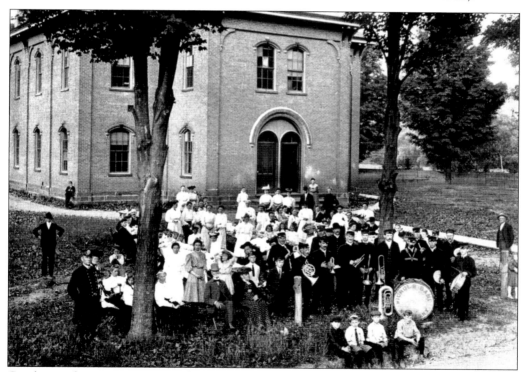

Candor residents came out to welcome the Nichols Kirby Band at the Candor Free Academy lawn as they gathered for the Fourth of July celebrations around 1908.

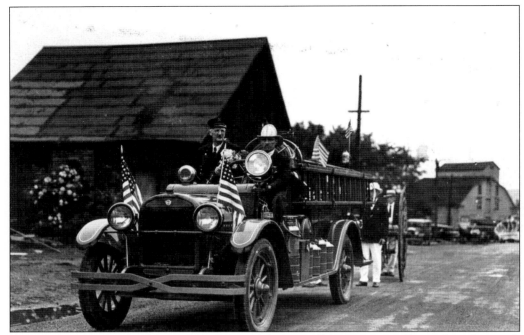

Will Beebe, the fire chief for many years, and driver Will Frost sit proudly on their fire truck that was purchased in 1925 for the Alpha Hose Company as they wait on Railroad Avenue (now Del Ray Avenue) for the 1931 Fourth of July parade to get underway. The old Sackett's Mill is in the background.

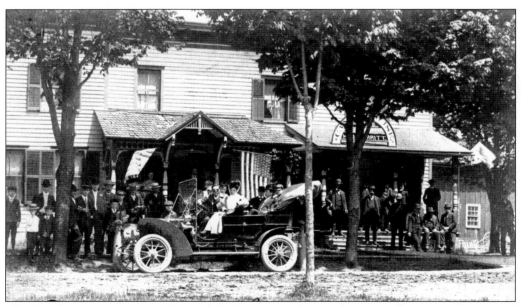

The Candor House on Main Street (also known as the Woolever Hotel) was the location of many social gatherings such as the one pictured, whether it was a military reunion, the Fourth of July celebration, or a family reunion. (Courtesy of Thomas McEnteer.)

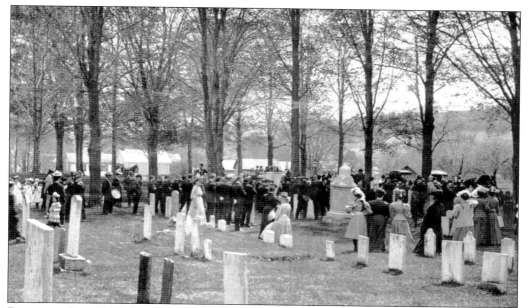

From as early as 1907, Candor residents came out to celebrate Memorial Day to honor veterans with a parade and services at the Maple Grove Cemetery. Candor continues this tradition today. (Courtesy of Thomas McEnteer.)

In 1907, the Al F. Wheeler Circus performed at the athletic field in Candor. In 1903, the Sun Brothers Circus came to town on its 11th annual tour. After the Grand Picturesque Street Parade there were performances by acrobats, trained horses and ponies, ladder performers, a rope-walking mule, a juggler, horizontal-bar experts, and the flying trapeze all under the big tent. (Courtesy of Thomas McEnteer.)

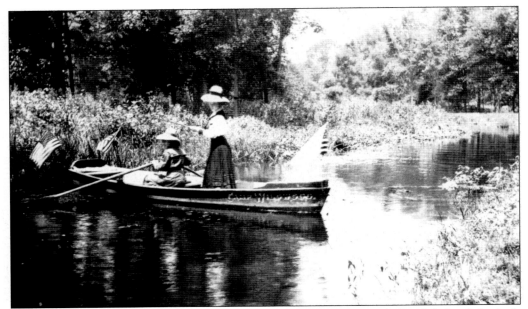

Mildred Woolever Heath is paddling Nina Brown across the Catatonk Creek behind the high school in the early 1900s. The two are on their way to Camp Wild Wood on the island where they often camped, or roughed it. They often took their friends to the island where they spent many carefree and fun-filled days.

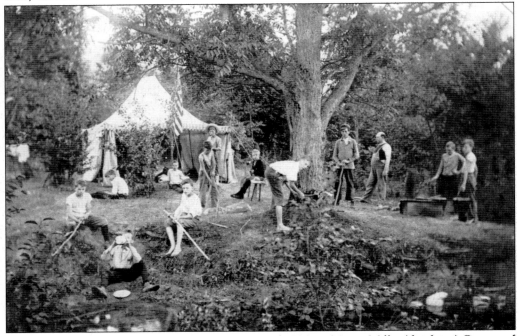

Among those enjoying a camping experience around 1906 are Myron Miller (drinking), Raymond Yonkers fishing (left), and William Phillips (right). Behind them are Arthur Beebe, Herman Andrews (next to the tree), and Rev. Clough Councillor. Edmin Menzies is on the opposite side of the tree. Ralph Cunningham, Harry Cunningham, and Merritt Roe are also pictured.

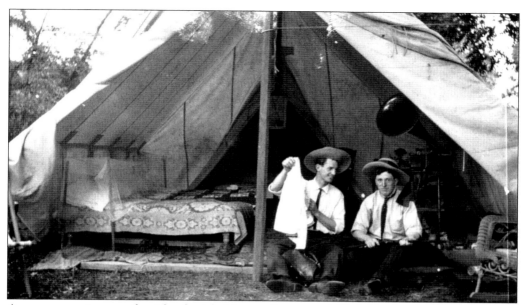

Anyone camping on the island with Homer Brown and Karl Heath of the Heath Coal Company went in style. Looks like these guys know how to set up camp with all the comforts of home. Camp Wild Wood (below) was no less of a hardship when it came to camping. These ladies, family and friends of Heath, enjoy their home away from home. (Courtesy of Sandra DePuy Brown.)

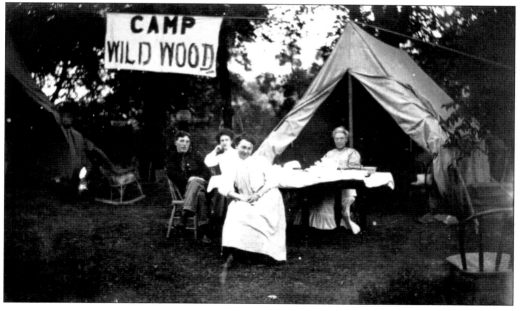

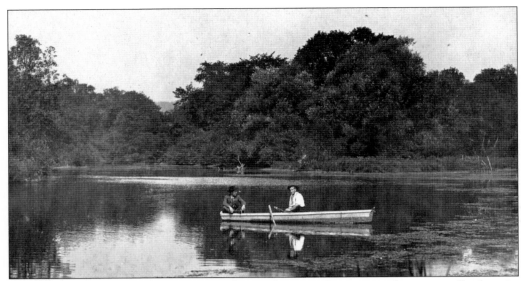

The Catatonk Creek was a great source of not only energy for running the many mills along its course, but it was also a great place for fishing, canoeing, and swimming. In the late 1900s, the Catatonk Creek between Candor and Owego afforded much pleasure and competition as the Catatonk Canoe Regatta ran annually in April.

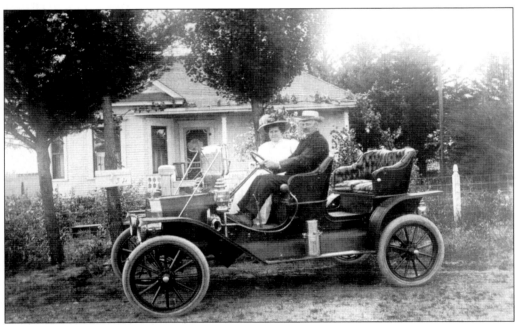

Willseyville residents Jerome Stevens, a dentist, and his wife get ready for a drive in their new automobile. (Courtesy of Thomas McEnteer.)

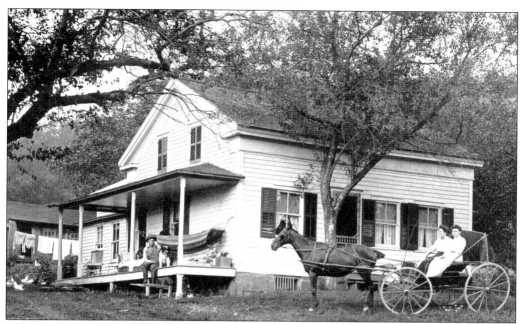

The Louis Willard home was located in Prospect Valley, a small community between Gridleyville and Willseyville. Willard's father was an electrician. (Courtesy of Thomas McEnteer.)

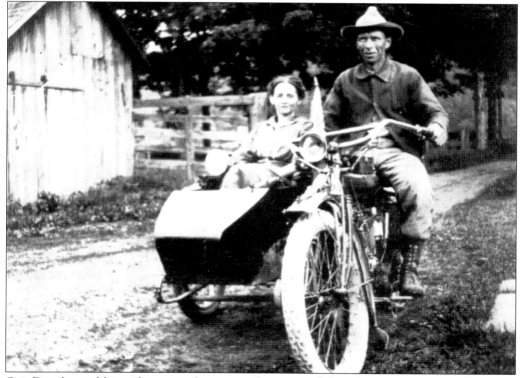

Otis Douglas and his wife try out their new sidecar motorbike. The Douglases lived in the old Bunnell brick home on the Spencer Road. The Blinn family now lives there.

On the farm, from left to right, neighbors Clinton Stevens and Bob and Frank Manning of Willseyville are most likely discussing and comparing yield, weather, and farm prices. (Courtesy of Thomas McEnteer.)

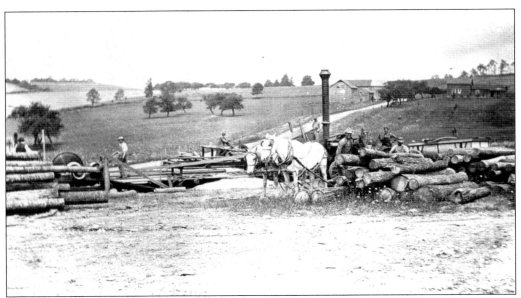

Pictured around 1900, Rhoma Dykeman's team on Hands Hill in Willseyville was a big help to the logging industry. Logging was a booming business around Candor and Willseyville in the early days, as it is today.

In 1920, Alison M. Lane built a large, new entertainment hall in Willseyville. It opened with a stage show by local talent doing *Aaron Slick from Pumpkin Crick*. Pultz's Orchestra provided the music. Admission was 15¢ for children and 25¢ for adults. Later a dramatic club was formed in Willseyville and took over the scheduling of the performances. Lane's Hall is no longer standing. (Courtesy of Georgia Westgate.)

The Candor Community Club held many programs, including hosting this band that performed at the Candor Town Hall. Candor was well known for the many talented entertainers that came from near and far. People rode the train to town and even stayed in the small hotels sprinkled around the village just to enjoy many of the programs and plays. (Courtesy of Thomas McEnteer.)

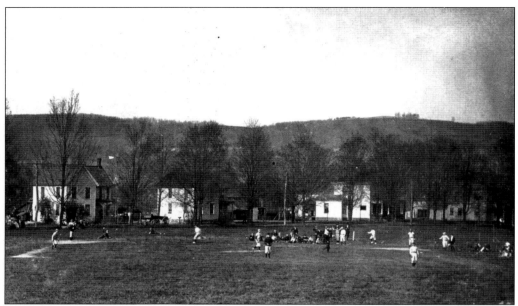

John J. McCarty, of McCarty and Payne's store on the corner of Spencer Avenue and Mill Street, bequeathed land to the village for an athletic ball field in 1935. Over the years, Candor's Fourth of July annual celebration events have been held here, including a ball game or two.

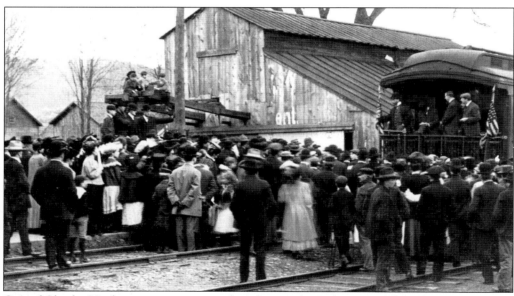

One of Charles Hughes campaign stops takes place at the Delaware, Lackawanna and Western Railroad station in Candor. With an endorsement from Theodore Roosevelt, Hughes ran successfully for New York governor, defeating Democrat William Randolph Hearst in 1906. In 1910, Hughes accepted the nomination to the high court from Pres. William Howard Taft. Six years later, he resigned and ran unsuccessfully against Woodrow Wilson for the presidency. (Courtesy of Thomas McEnteer.)

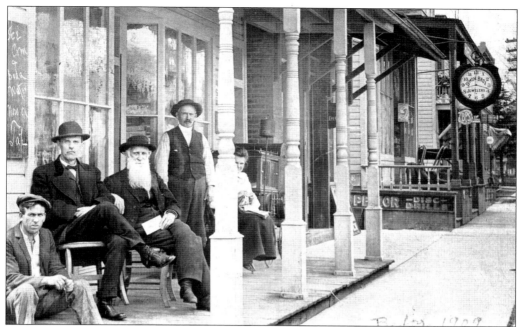

It was not unusual to find neighbors sitting a spell on the boardwalk in front of businesses along Main Street in Candor around 1909. Seated from left to right are unidentified, F. Smith, Aldin Robinson, Charles Martin, and Eva Martin behind the post.

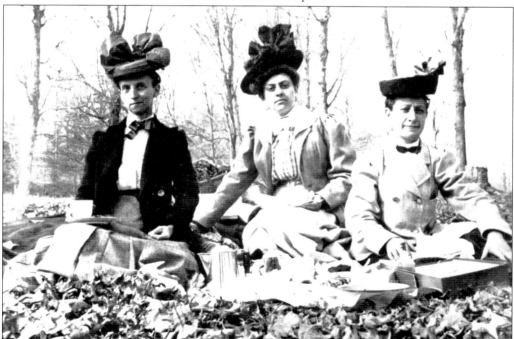

In October 1908, these three graces enjoy an outing among the fallen leaves. From left to right, Mary Fiebig, Anna Personius, and unidentified, seem to be enjoying a spot of tea in the great outdoors.

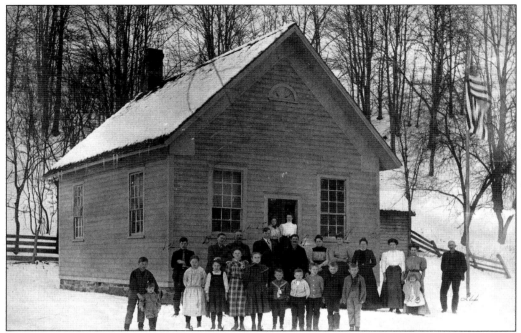

The Upper Shendaken Country School, located on Prospect Valley Road, celebrated Christmastime with a special program around 1900. Pictured are the Russell, Quick, Rice, Hurd, Young, and Van de Mark families.

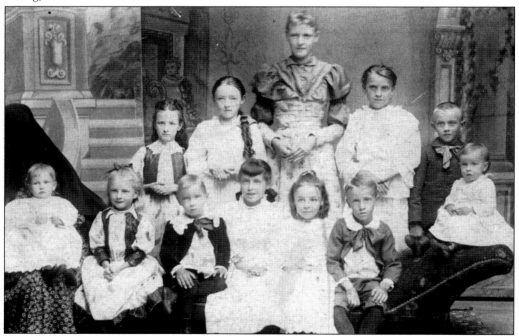

It is hard to get families together these days to take group pictures, but in 1892, the great-grandchildren of Michael Parks and Roxey Cass Dikeman and the grandchildren of William S. and Mary Elizabeth Hart Dikeman came together for this great family portrait.

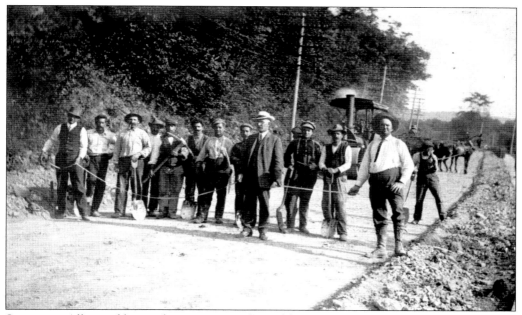

Supervisor Allen and his road crew measure the width of the new road going through while the steamroller idly stands behind, waiting to compact the earth.

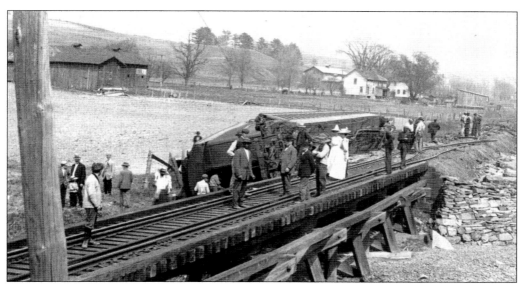

The Lehigh Valley Railroad's Elmira and Cortland branch ran four trains a day through West Candor. The train left for Elmira (from Cortland) at 10:29 a.m. and 7:01 p.m. and for Cortland (from Elmira) at 8:12 a.m. and 4:52 p.m. Curious onlookers line the tracks to check out the damage to the wrecked train on the West Candor tracks around 1910.

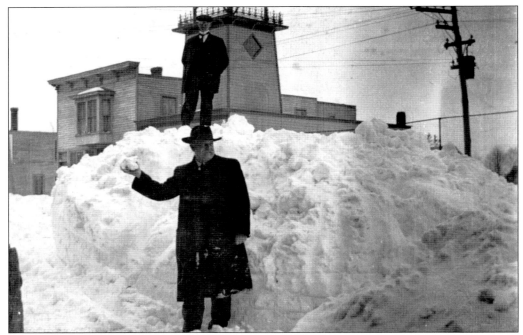

Bruce Fessenden's grandfather stands on top of a pile of snow while Charles F. Fiebig stands below. According to reports, the snowstorm of March 1, 1914, was one of the worst of the century in Candor. The Alpha Hose Company building is in the background; to the immediate left is the Grange hall.

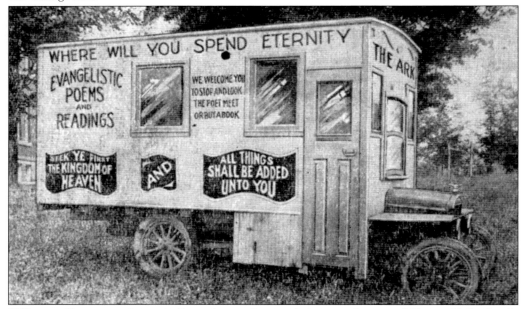

"Where will you spend eternity" are the words sprawled across the top of George F. Roe's ark, pictured above in the 1920s. Before he became an Evangelist, Roe, known as Fred, was the iceman in Candor. He lived above his shop at 72 Main Street where he sold meat and fish. Roe peddled his word of the Lord throughout Candor, Tioga County, and even into Potter County, Pennsylvania.

Six

TOWN AND COUNTRY VIEWS

Many of the small communities that make up the town of Candor are rural farming communities. Even the land surrounding the village of Candor has rural rolling hills with a wide valley as this 1910 picture reveals. In the center background, the McKendree United Methodist Church steeple stands out.

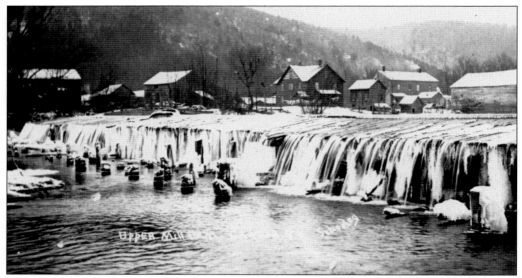

The upper dam and millpond on the Catatonk Creek fed one of Candor's two major mills in the village. In the winter when the water froze, iceman Fred Roe harvested ice and stored it in sawdust for the summer months. The homes and businesses shown in the picture above were accessible along Factory Street (now McCarty Street), including the Wands Glove Factory. The picture below shows the homes along Route 96B, looking north on the opposite side of the dam and the Catatonk Creek.

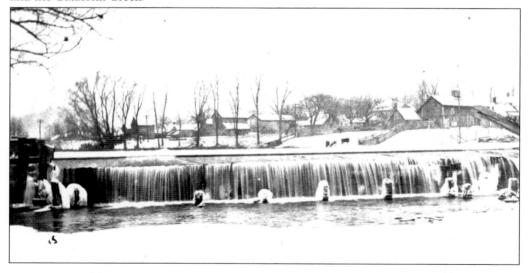

Both the old upper mill and the old bridge along North Mill Street were taken down in 1986 to make way for a new bridge. The mill was vacant for some years. After it was removed, the village put up a small park in its place. The house on the right was the original Alfred Smith home, built around 1905. The home was taken down in 2000.

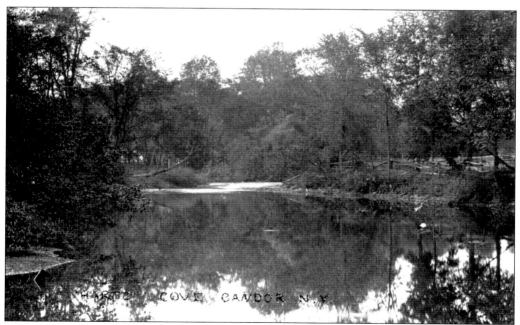

Harts Cove along the Catatonk Creek south of the upper dam was a popular location for fishing and canoeing. (Courtesy of Thomas McEnteer.)

Carl Baker, postmaster for a time, lived on Factory Street, now McCarty Street, which ran from Mill Street west along the athletic field. Baker's house is on the left.

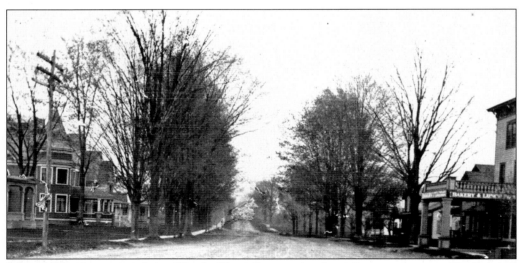

Edward Wands, owner of the Wands Glove Factory, lived on Spencer Avenue. His home is pictured on the left. For a time in the mid-1900s, the house was used as a nursing home, but is once again a home. This street was the main route from Candor to West Candor then on into Spencer. On the right is a bakery that served lunch.

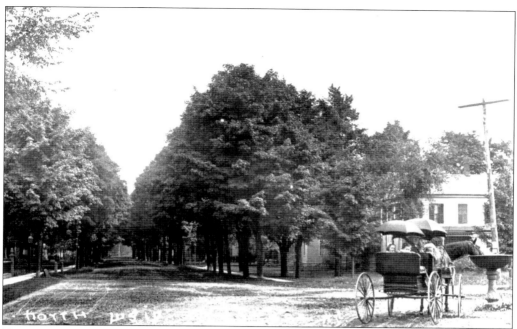

Next to McCarty and Payne's store on Main Street, Mill Street, and Spencer Avenue, John W. McCarty had a water fountain installed for horses in 1904. The house in the background behind the thirsty horse was the Nathan Turk residence. It is now a funeral parlor.

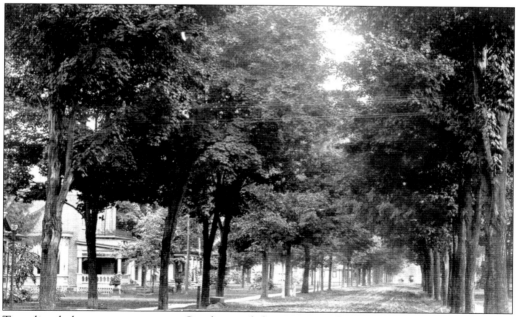

Trees lined almost every street in Candor until they were cut down in 1956 to widen the roads. From Kinney Street looking down Main Street toward the business section, they hide the large, imposing homes that also lined Main Street.

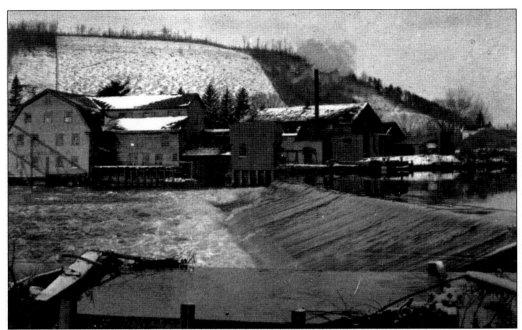

Once a large part of the mill industry in Candor in the 1800s and 1900s, the lower dam has had several repairs over the years. The above picture shows the original location of the lower dam and the flume in the foreground. The flume brought water into the mill and was controlled by a gate at one end that closed off the flow when it was not needed. In the background are the woolen mill (far left) and the blanket factory (center). After one such repair, the dam pictured below was moved back and the angle of it changed. The mill ceased operation in the mid-1900s and was torn down in 1986. In recent years, the dam was in need of repair once again. After a failed feasibility study to obtain funding to repair it, the lower dam was removed in 2005. (Above, courtesy of Howard Weber.)

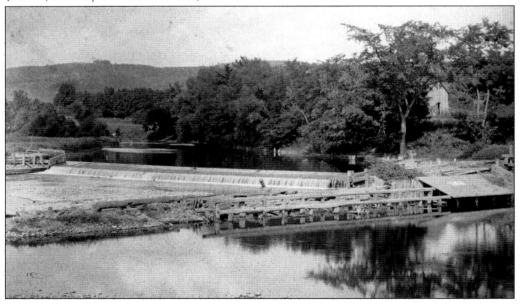

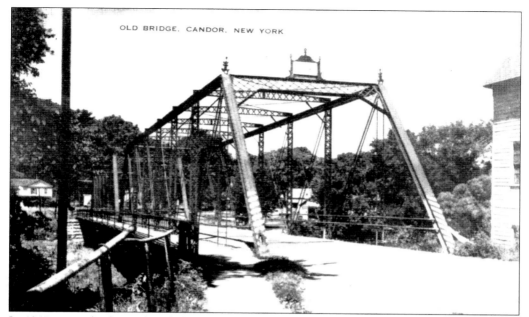

OLD BRIDGE, CANDOR, NEW YORK

In 1949, a new bridge replaced the one pictured, which allowed for two lanes and sidewalks on either side. The old bridge was made of steel trusses and girders. The lower dam was on the right of the bridge, and the old Delaware, Lackawanna and Western Railroad bridge ran alongside on the left.

The back road from Tallow Hill Road to Gridleyville, near West Candor, still follows the Catatonk Creek on its way through the town of Candor. This road is now paved through the town of Candor toward the Spencer town line, and although it is still scenic, there are several cottage-type homes that have sprung up along the creek.

Various mills operated in the small communities along the creeks that ran through Candor, such as the one pictured above that was located in the West Candor area along the Catatonk Creek.

The Catatonk Creek provided good opportunities for fishermen like Clinton German in 1925, who is trying his luck at Art Woodford's place in Gridleyville.

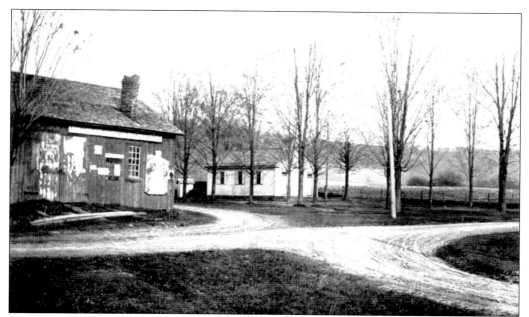

Pictured in the late 1800s, the four corners of Hubbard Town was typical of many early settlements. On the right of the intersection is the old schoolhouse on Howard Hill Road; to the left is an old blacksmith shop. The road running horizontal is the main road to Owego (now Route 96), and the one in the right foreground was the back entrance to Kelsey Road.

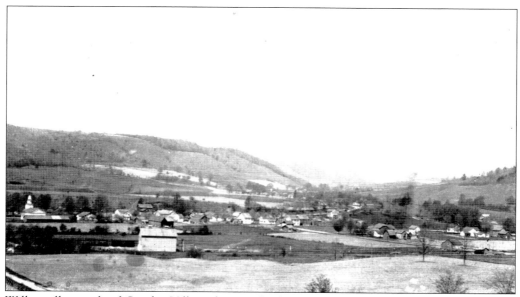

Willseyville, north of Candor Village, lies on the border with Tompkins County. In 1911, the creamery, in the foreground on the left, was situated along the Delaware, Lackawanna and Western Railroad. To the left is the Baptist church and the main business section of the small village.

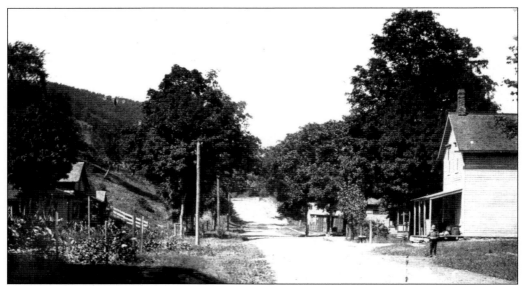

The main route between Ithaca and Owego was part of the old turnpike, and it ran through Willseyville. It was not until the 1940s that the state came through and straightened the route so that it ran behind the village. An early glimpse of the old, well-worn byway in the picture below shows just how close to the homes wagons and later cars passed along the way. At one time, it is documented that as many as 800 teams of horses traveled between Ithaca and Owego.

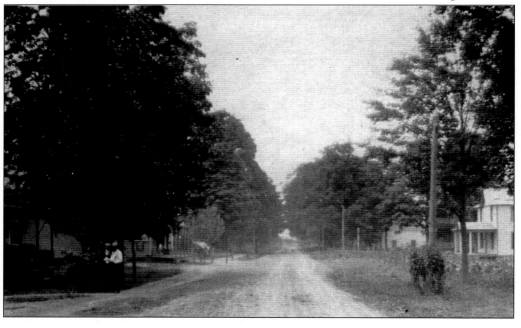

Prospect Valley, between Willseyville and Gridleyville, sometimes referred to as Shendaken Hollow, was a separate community with two schools, a church, and stores that later sold gasoline when the automobile came along. Today although the paved road is lined with homes, it is a rural community minus the schools, church, and stores. (Courtesy of Thomas McEnteer.)

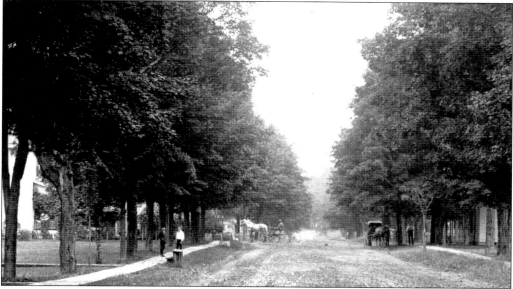

In 1914, North Owego Street in Candor, from Mountain Avenue looking south, was a dirt thoroughfare lined with mature trees that provided plenty of shade. There was plenty of room for horses and wagons to pass each other in this section of the tree-lined turnpike that ran from Ithaca to Owego, with sufficient space to tie up alongside the road. Sidewalks were a necessity, especially during the rainy, muddy season.

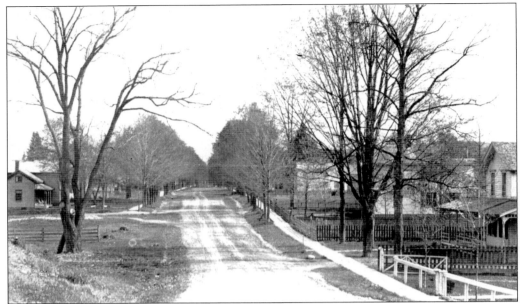

Trees line the narrow and unpaved road on North Owego Street looking south. The house pictured on the left is situated along Mountain Avenue.

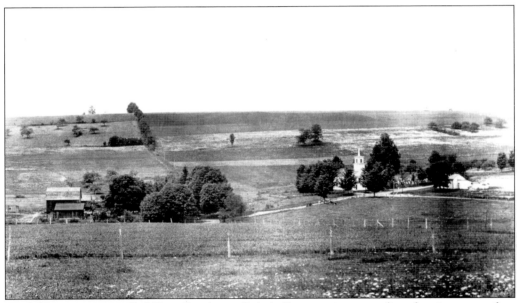

Fairfield, sometimes called East Candor or Lake's Corners, is a sprawling farming area often divided into Upper and Lower Fairfield. Upper Fairfield, pictured around 1900, provided plenty of rolling hills for farmers to put in crops for their herds. The old church to the right is no longer standing. Across the road from the cemetery is the old district school.

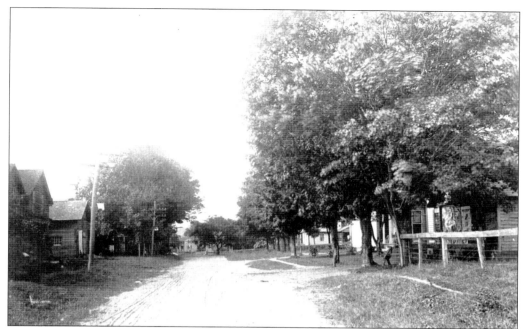

In 1909, Weltonville, also part of the town of Candor, lies to the southeastern portion of town along the West Owego Creek and at the foot of Lower Fairfield. Weltonville was a rural farming community with a blacksmith shop, a church, and a general store. Later the general store added gas pumps.

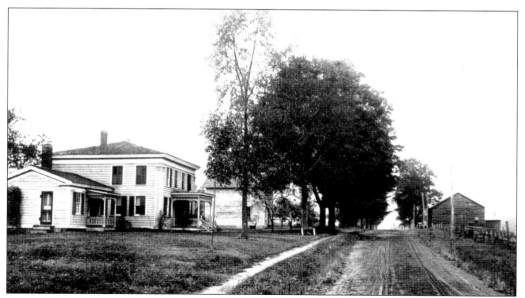

Many years ago, Catatonk's Main Street was dotted with farms and nothing much in between but a tollbooth on the Ithaca–Owego Turnpike. The narrow path on the left suggests a sidewalk of sorts, although today there is no sign of a sidewalk in this built-up area. (Courtesy of Thomas McEnteer.)

The Cookie Jar Restaurant was started in 1926 by Albert Moree and Seaman Zilch and was moved to this location in Hubbard Town from the village of Candor. In 1936, the Brush and Pallette Tavern became part of the restaurant and was in business well into the late 1900s. In 1987, most of the building was razed and the remainder converted into an automobile sales establishment. (Courtesy of Thomas McEnteer.)

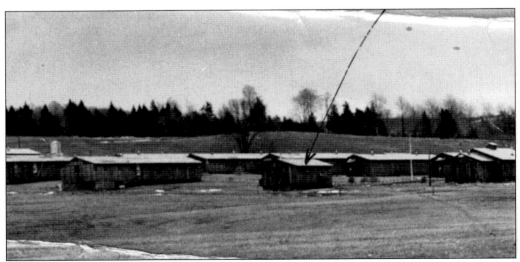

Construction was started on the Civilian Conservation Corps (CCC) camp at Straits Corner in Candor in 1935. The projects included erosion control, electric-line construction, flood assistance, and a wood-lot survey. The CCC was largely responsible for planting trees in the area. (Courtesy of Milton Dougherty.)

Seven

ONE LAST LOOK

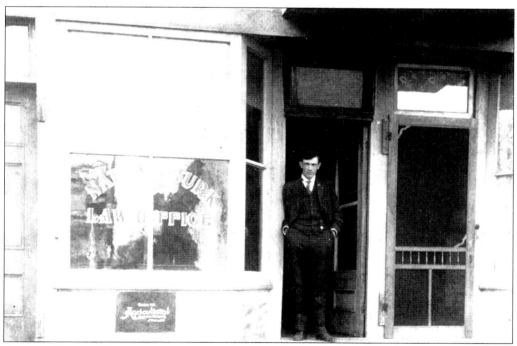

A young Nathan Turk, pictured, was a graduate of Candor High School in 1906. Turk returned to Candor and opened a law office in 1912. He was a member of the Candor Masonic Lodge No. 411 and was appointed grand master of the State of New York. Camp Turk, a campsite in the Adirondack Mountains, is run by Masons for friends and children of Masons and was named in his honor.

Lumbering and tanning were big businesses at the dawn of the 20th century, and there were several mills that operated throughout the town. Today sustainable harvesting of trees and milling is one of the main industries in Candor. (Courtesy of Joan Beebe Meddaugh.)

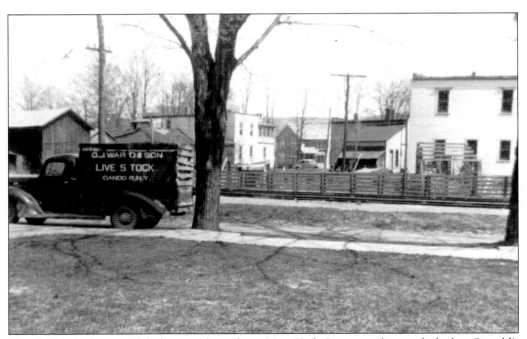

Oswald J. Ward was widely known throughout New York State as a livestock dealer. Oswald's son Kenneth joined him, and together they shipped thousands of cattle and sheep from their own stock loading pens at the Candor railroad station. (Courtesy of Joan Beebe Meddaugh.)

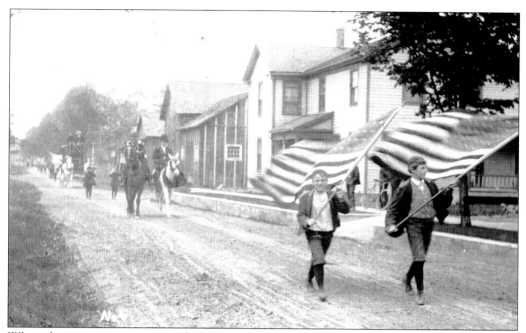

When the circus came to town, there was sure to be a parade. The two flag-carrying youngsters had the opportunity to lead the procession in one such parade in 1908. (Courtesy of Thomas McEnteer.)

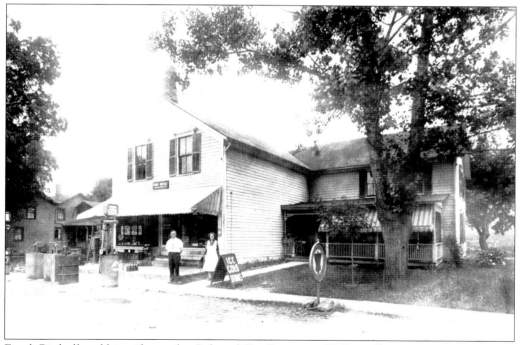

Frank Birdsall and his wife ran the Colonial Gas Station in Willseyville on Main Street around 1927. They also had the post office for a time. (Courtesy of Thomas McEnteer.)

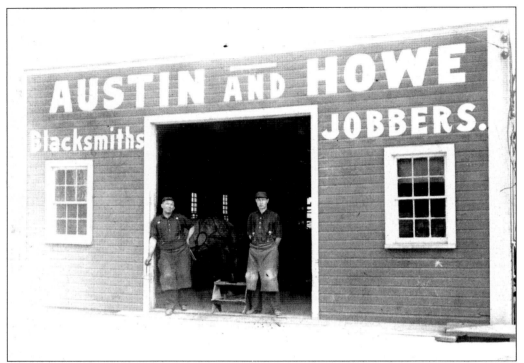

Strait's Corners was a thriving community on the southwestern end of Candor. This photograph shows Austin and Howe, owners of the blacksmith shop located there. (Courtesy of Thomas McEnteer.)

In 1919, this parade was relegated to the sidewalks along Main Street, most likely due to a muddy, rutted highway. These participants just walked past the old woolen mill and horse blanket factory.

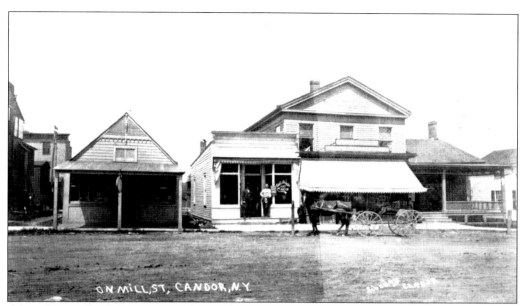

A broad view of Mill Street pictured around 1910 shows several of the businesses, like the ice-cream shop and Betty's Lunch. In the 1950s, the Candor Fire Department garage was located here.

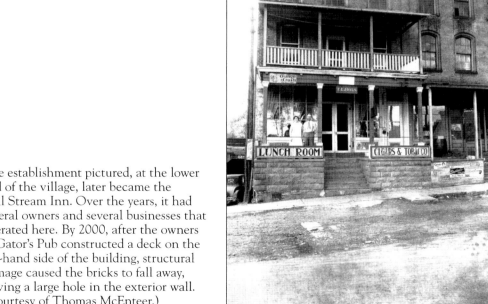

The establishment pictured, at the lower end of the village, later became the Mill Stream Inn. Over the years, it had several owners and several businesses that operated here. By 2000, after the owners of Gator's Pub constructed a deck on the left-hand side of the building, structural damage caused the bricks to fall away, leaving a large hole in the exterior wall. (Courtesy of Thomas McEnteer.)

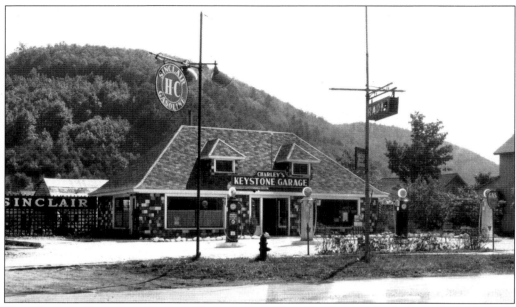

The Keystone Garage on Spencer Corners was sold to Charles A. Marshall in 1926. Marshall was the mechanic at the time, and W. L. "Doc" Badgley, who was a local horse doctor, was the owner. Over the years, this establishment changed hands several times and in more recent years was the Loft Restaurant that is now closed. (Courtesy of Thomas McEnteer.)

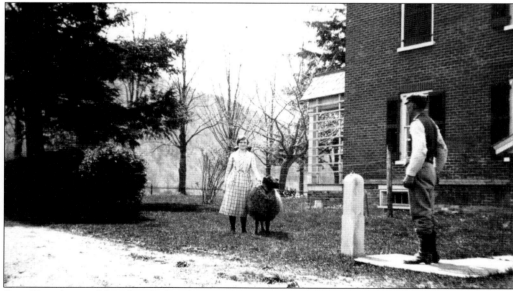

Otis Douglas and his family lived on Spencer Road in the house now owned by the Blinn family. It was built with bricks from the Bunnell Brick Company, later called the Candor Brick Company. Douglas is standing next to the hitching post at the end of his sidewalk next to the highway, while his daughter Georgia stands beside her pet lamb.

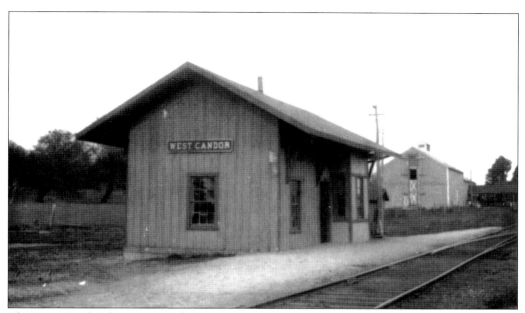

The West Candor depot, pictured above, and Snyder Station depot, pictured below, both serviced the Utica, Ithaca and Elmira Railroad starting in 1875. The railroad ran through Willseyville, Gridleyville, West Candor, Spencer, and then Elmira. In 1884, it was sold and renamed the Elmira, Cortland and Northern Railroad. In 1896, it was sold again to the Lehigh Valley Railroad as the Cortland branch. This route was discontinued in 1935. (Courtesy of Thomas McEnteer.)

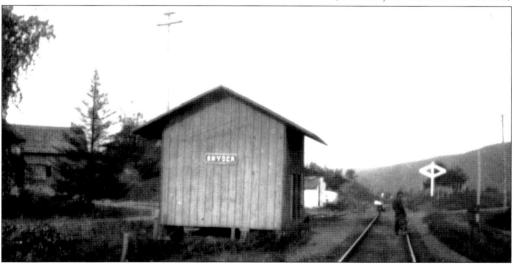

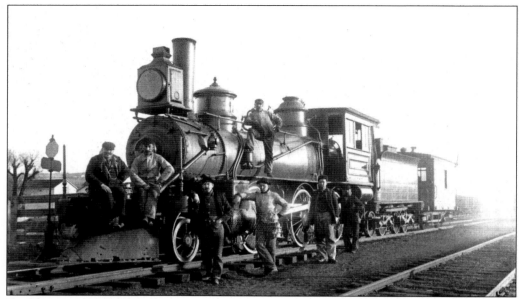

Coal-burning locomotives that roared through Candor on a regular basis were a marvel in their time and a sight to behold every time one passed through town. Posing next to these powerful iron horses was an honor.

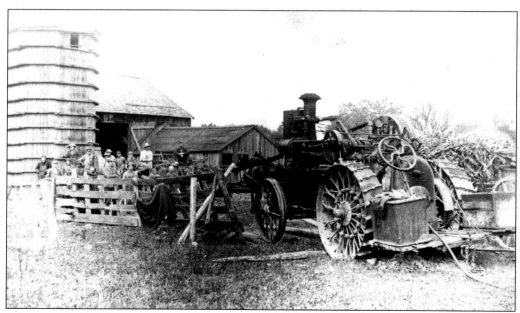

When newfangled farm equipment showed up at the Wheeler farm, everyone came out to see it in action, keeping at a safe distance behind the fence, of course. (Courtesy of Thomas McEnteer.)

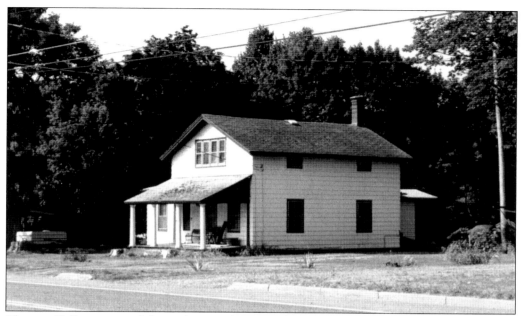

Thomas Hollister, one of the earliest settlers, was the first to build his home opposite the old Native American fort that was located where the Maple Grove Cemetery is today. The house pictured is the earliest home still standing in Candor, and although it has had a bit of renovation over the years, the main structure is the original home built in the 1790s.

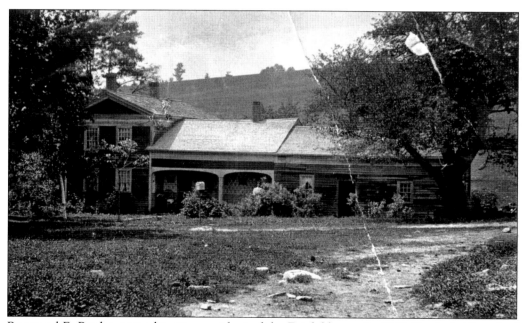

Raymond E. Barden was a longtime resident of the Fairfield area. In 1905, Barden's Cloverleaf farm (pictured) offered choice handpicked fall apples for 75¢ a bushel, choice handpicked winter apples for $1 a bushel, and handpicked winter seconds for 75¢.

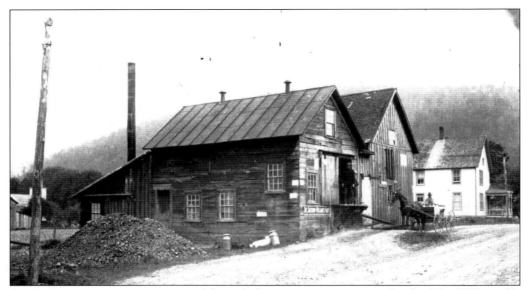

A creamery was an important part of the early farming communities in Candor. The Willseyville Creamery was strategically located next to the Willseyville Creek and the Delaware, Lackawanna and Western Railroad tracks. The building was added onto as needed until a newer creamery was built, later owned by Borden's Milk Company.

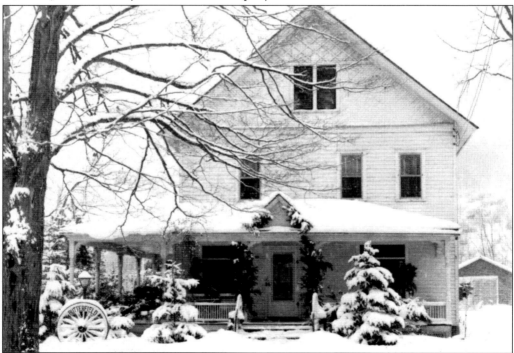

Dr. M. B. Dean was a local health officer who lived at 19 Stowell Avenue. In 1905, Dean, along with the other doctors in the community, fixed their rates. An office call was 50¢, and a house call in the village limits was 75¢. Outside the village, rates were proportionate on the distance traveled.

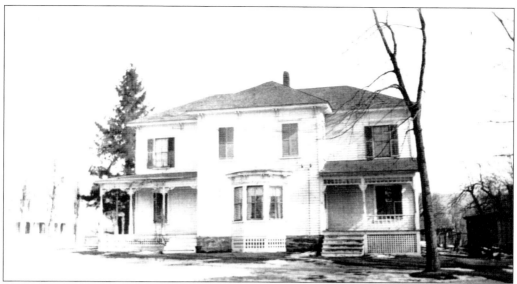

In 1949, Ray Cochran purchased the old home pictured above, dismantled it, and built the Cochran service station on the corner of Mill and Owego Streets. The lot was originally owned by Joseph Matthews, who sold it to Abel Hart Jr. in 1862. In 1872, Hart gave this property to his son George H. Hart, and he built the house pictured above. Alfred Smith built the house pictured below around 1905. It had a similar fate as the Hart house. In 2000, the new owner of the above service station, Dan Lindsey, having already purchased the property across the street at 39 Mill Street, applied for a demolition permit to have the historic Smith home razed. Lindsey later sold the property along with the gas station. (Above, courtesy of Howard Weber.)

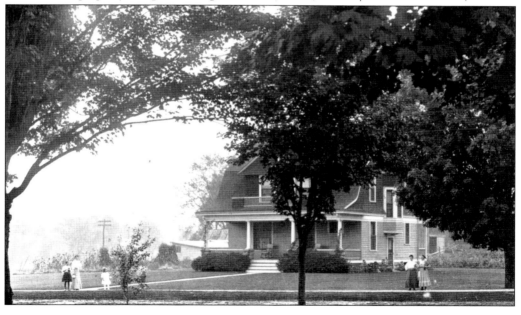

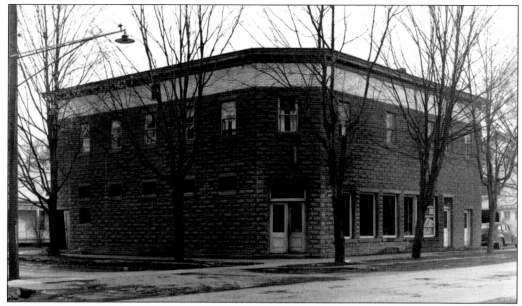

Originally built as a general store in 1906 by Almerion Johnson, it later became known as the White Elephant. In 1935, the White Elephant was the first to be granted a license for beer and wine. At that time, the owners did a bit of renovating (below), giving the interior a new look. When Lloyd Kirk purchased it around 1949, he carried out additional renovations in 1952 and renamed it Rendezvous Grill. It has had many owners over the years, remaining a bar, and is currently under new ownership. (Courtesy of Thomas McEnteer.)

Eight

NEIGHBORING TOWNS

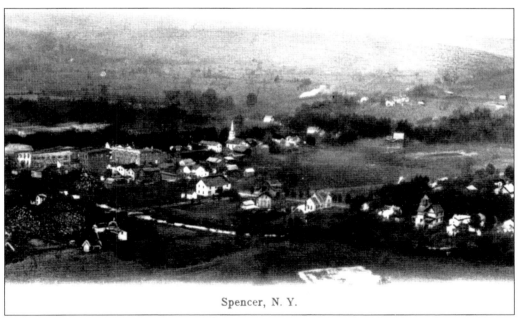

Spencer, N. Y.

Several small towns in Tioga County have connections to Candor, the closest being Spencer, which lies to the west. Originally known as Drake's Settlement, the town formed in 1806 and became known as Spencer. Between 1811 and 1822, Spencer was the Tioga County seat, complete with a courthouse. The village of Spencer incorporated in 1886. Candor was part of the town of Spencer until 1811 when Tioga County's lines were redefined. (Courtesy of Thomas McEnteer.)

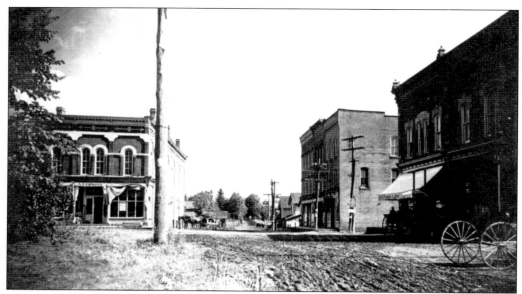

Spencer's Main Street in 1905 included the H. L. Emmons Department Store, pictured on the left, which was built in the 1870s. The building was taken down to put in a gas station. On the far right are the present offices of the Tioga State Bank, and directly next to it is the bank, the top portion having been removed. (Courtesy of Thomas McEnteer.)

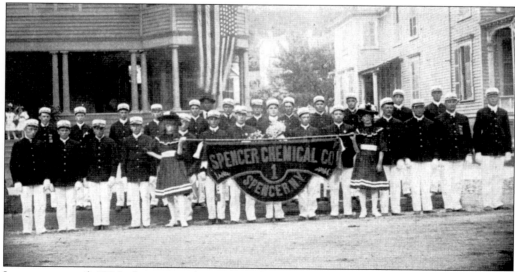

It was not until 1896 after many devastating fires in the town of Spencer that the Spencer Chemical Company No. 1 fire company was organized with a hose cart and a chemical engine. Marching in the town's parades was an annual event. (Courtesy of Thomas McEnteer.)

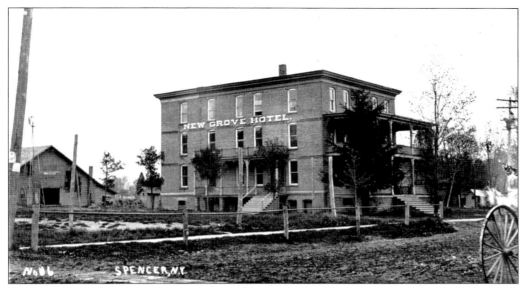

The first Grove Hotel in Spencer was a three-story brick structure that was built in 1890. However, the hotel burned a decade later, and the New Grove Hotel (pictured) was constructed on the same site by S. A. Seely. When Fred Risley bought it in 1925, he changed the name to the Risley Hotel. The hotel was torn down in the 1950s. (Courtesy of Thomas McEnteer.)

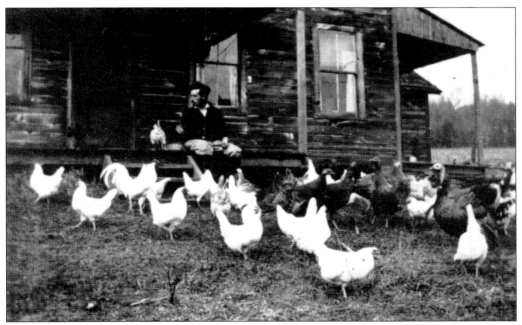

Labon Leonard bought the Dickerman farm on Crumtown Road in the town of Spencer. He took to chicken farming, most likely for the production of eggs, which was a big business in the Spencer area at the time.

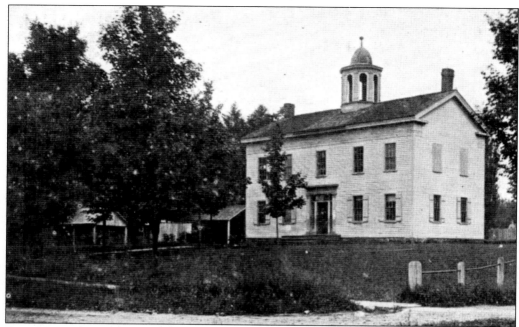

Spencer Academy (above), or the White School House, was located on the corner of Academy and Nichols Streets and served as District School No. 4. It was torn down in 1903 when a new brick school was built. The new school, pictured below, was used until 1935, when Spencer schools were centralized, and a new schoolhouse was built across the street. (Courtesy of Thomas McEnteer.)

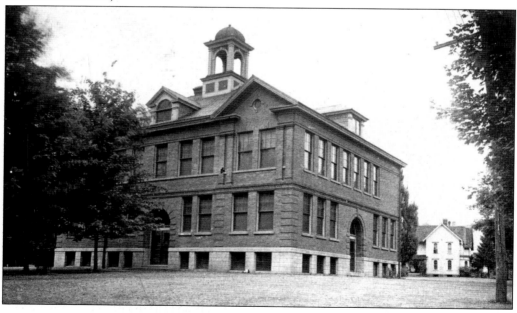

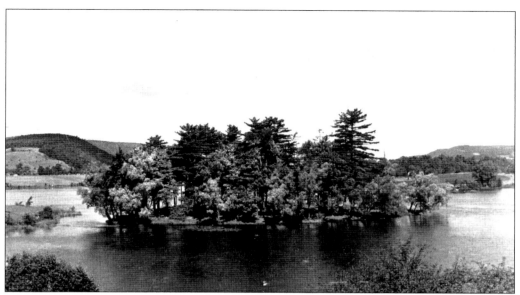

Spencer Pine Tree Island at Spencer Lake was once known as Bushy Island. A pavilion once extended out from the island about 100 feet over the water. Over the years, there have been many social events held on the island and around the lake. (Courtesy of Thomas McEnteer.)

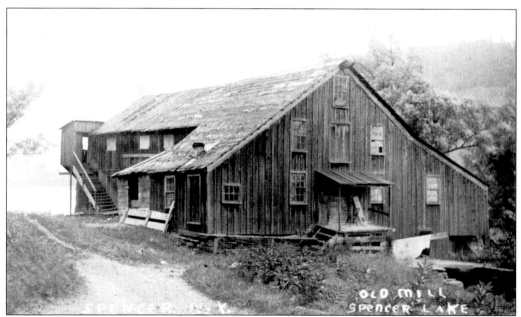

The old mill at Spencer Lake is one of several that sprang up along its shores. A dam was erected at the lower portion of the lake, flooding several acres of land and raising the water level. A water raceway turned the wheel that ground flour and feed on the millstones. The mill was in operation until the early 1900s. (Courtesy of Thomas McEnteer.)

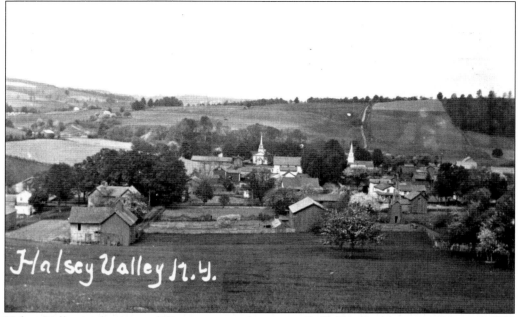

Halsey Valley in the town of Tioga was once known as Girl's Flat. It was surveyed around 1790 by Thomas Nicholson, who died in 1792. His daughter became his heir, which is how it acquired the name Girl's Flat. She died at age 18. His wife remarried Zephaniah Halsey, whose children then inherited the land, which became known as Halsey Valley.

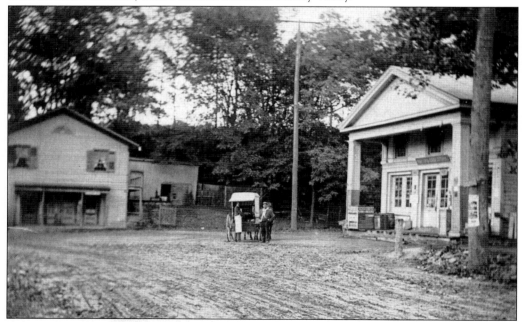

The former business section of Tioga Center was located in the area where Halsey Valley Road intersected with the Tioga Barton Road. This area was razed in 1930 when a new highway came through. Pictured is Fred Martin's general store where children could buy penny candy. A meat wagon has come to the corners. (Courtesy of Thomas McEnteer.)

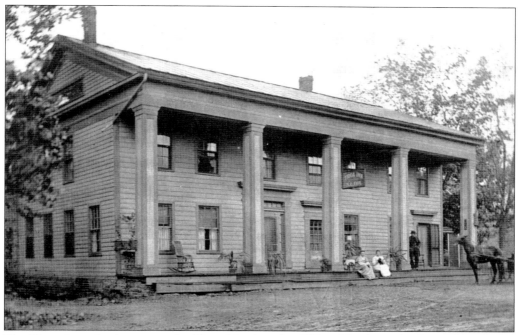

The Tioga Inn, also known as the Tioga Hotel or the O'Hart Hotel, run by Stuart E. Fox, was one of the buildings that was razed for the construction of Route 17C in 1930. It was used as a boardinghouse prior to demolition. (Courtesy of Thomas McEnteer.)

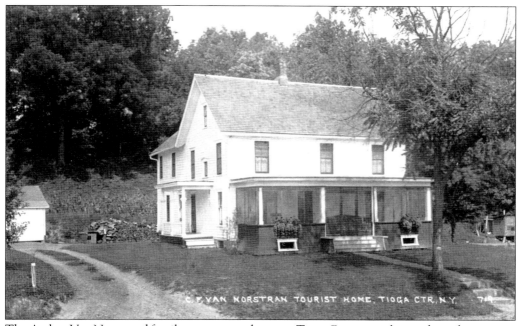

The Arthur Van Norstrand family ran a tourist home in Tioga Center similar to what is known as a bed-and-breakfast today. Arthur was also the town supervisor. (Courtesy of Thomas McEnteer.)

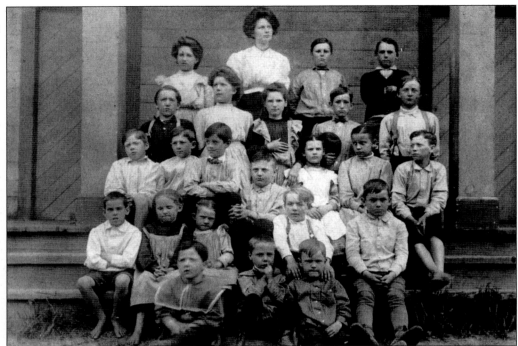

Halsey Valley District School students in 1909, from left to right, are (first row) Aldis Robinson, Homer Thomas, and Clyde McDuffy; (second row) Fred Bensley, Mildred Bensley, Bernice Barber, Lyman Frisbie, and unidentified; (third row) Sibley Barber, LaVere Doane, Shirley West, Harold Doane, Helen Barber, Edna Fraley, and Orris Root; (fourth row) Chet Cassedy, Hazel Barber, Stella Barber, Warren Bensley, and Harry Barber; (fifth row) Edna Barber, Leah Doane, Harry Frisbie, and Howard Thomas. (Courtesy of Thomas McEnteer.)

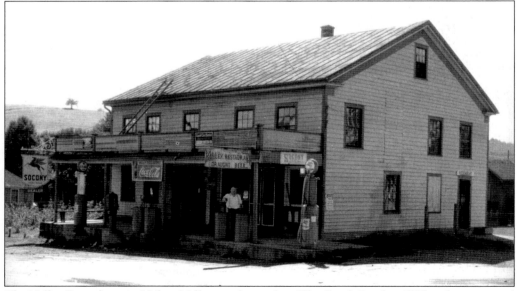

The Valley Restaurant in Halsey Valley was located on Ellis Creek Road in 1935 and maintained Socony gas pumps and draught beer for their customers. (Courtesy of Thomas McEnteer.)

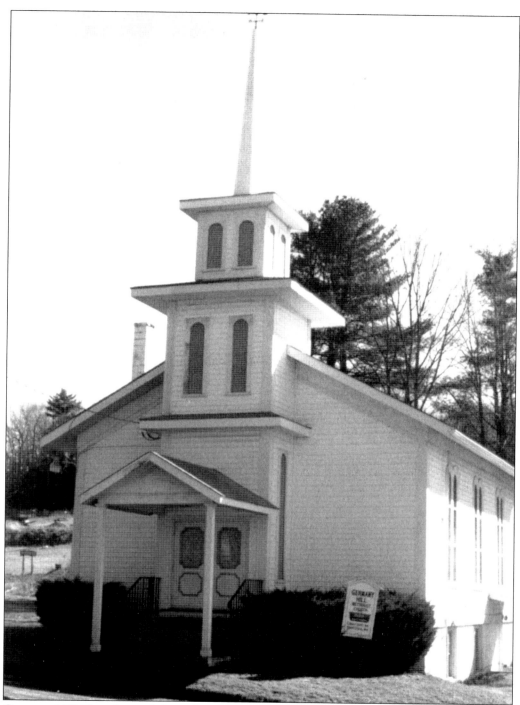

Germany Hill Church was dedicated in 1870 by German immigrants that settled the area. Many people living in Candor belonged to this church. The land was given by George and Magadaline Ahart and Nicholas and Sophia Ott in 1868. In 1950, the church was moved back from its original site and is still functional today.

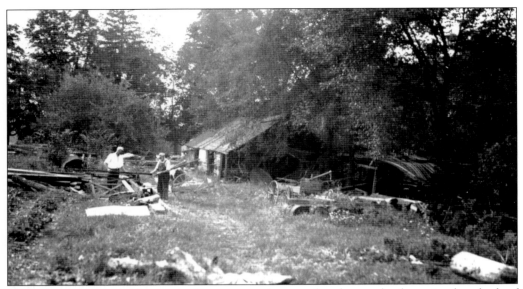

H. N. Dean and Son's Tannery in Owego turned out card and russet leather using hundreds of cords of bark yearly in the late 1800s. The tannery was located on North Roe and Dean Streets. In 1937, Mr. Root (right) was the mill owner. (Courtesy of Thomas McEnteer.)

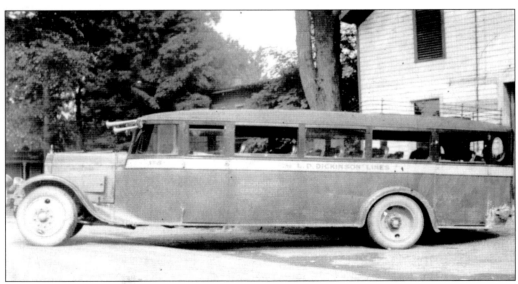

Leonard D. Dickinson founded the Dickinson Coach Line in Owego in 1920. Dickinson's first bus route made three runs between Owego and Spencer. Later Dickinson had a run to Ithaca, passing through Catatonk, Candor, and Spencer to take workers to the Morse Chain Factory. The bus held 16 people. (Courtesy of Thomas McEnteer.)

Owego's Front Street, pictured above around 1930, is adorned for one of the town's annual patriotic celebrations. Although a year late, Owego celebrated its sesquicentennial in 1938, holding events between July 1 and July 5 (below). Along with a firemen's convention that year, there was a large parade and other special events that took place at Marvin Park. (Courtesy of Thomas McEnteer.)

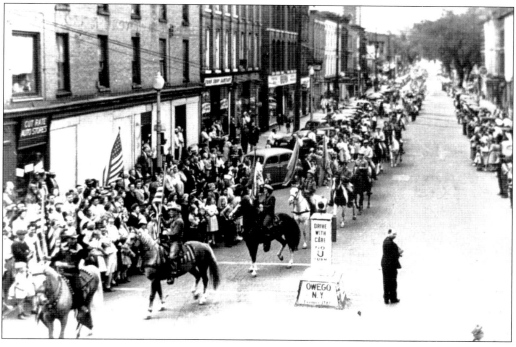

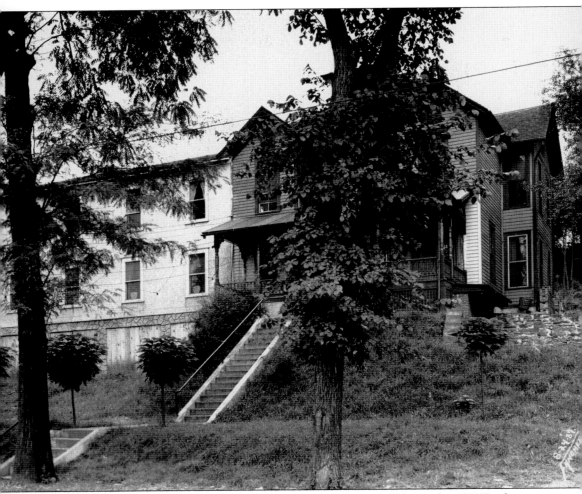

Many communities had dance halls in the 1930s. Owego's dance hall, located at 278½ Lackawanna Avenue was considered grand and was a popular place where people could socialize. (Courtesy of Thomas McEnteer.)

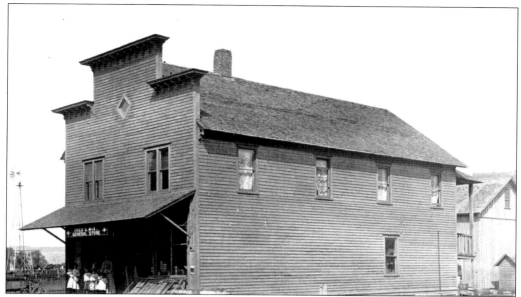

Located on the northeastern edge of the town of Owego, Flemingville was a successful farming community. In 1902, the Lehigh Valley Railroad came through. With the train came the post office, which closed in 1932. The community also had a general store, a feed mill, a creamery, a stockyard, and a coal shed. As many as eight trains stopped there daily. Pictured above around 1900, the Fred G. Mix General Store in Flemingville was one of a number of stores that serviced the needs of the small community. Another store, pictured below around 1917, was Nixon's Store. (Courtesy of Thomas McEnteer.)

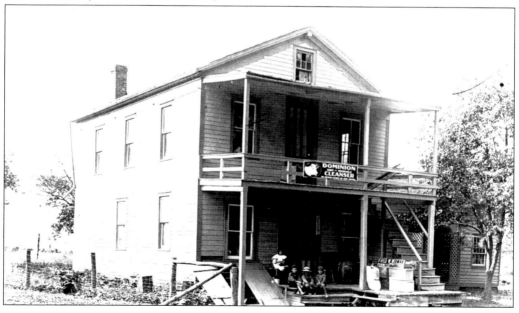

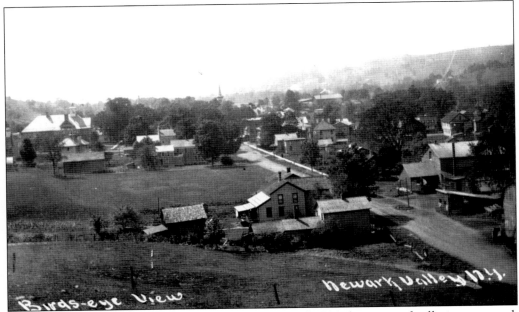

Newark Valley was settled in 1791, but it was not until 1894 that it was finally incorporated. In the early years, it had many names, including Brown's Settlement, the Society of Western, Westville, Newark, and finally in 1862, it gained its present name of Newark Valley. (Courtesy of Thomas McEnteer.)

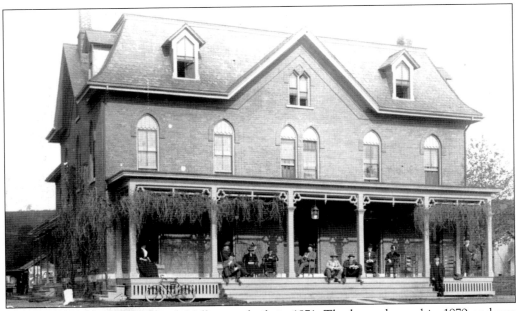

The Dimmick House in Newark Valley was built in 1871. The house burned in 1879 and was rebuilt the following year (above). In 1948, the Newark Valley Servicemen's Memorial Home operated the building for a clubhouse and apartments. The clubhouse was sold around 1960 with the proceeds of the sale donated to the library and the emergency squad. The building was razed in 1963. (Courtesy of Thomas McEnteer.)

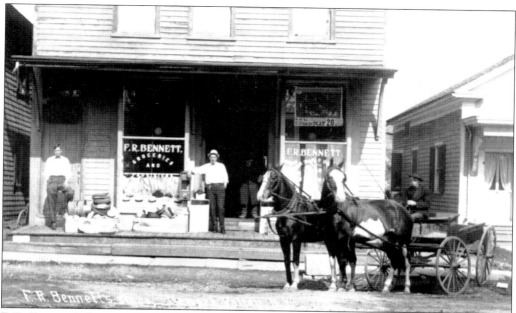

F. R. Bennett's Store, pictured above around 1910, was one of several stores in Newark Valley that sold groceries and dry goods. The main business section in Newark Valley ran along Water Street, pictured below in the 1930s. Between 1910 and 1930, automobiles replaced horses, making coming to town to shop more feasible to those in the country. (Courtesy of Thomas McEnteer.)

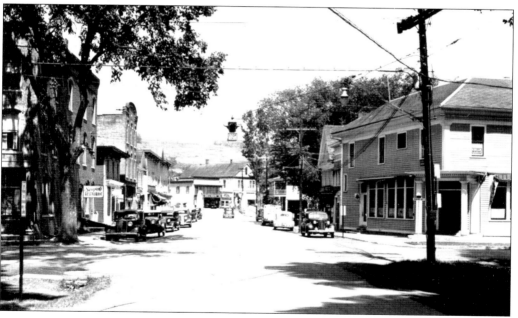

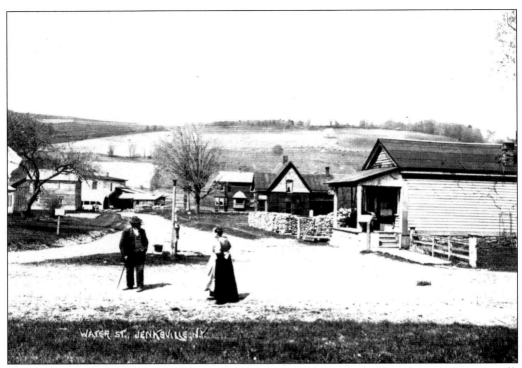

Jenksville was settled around 1797. In 1803, Michael Jenks built a sawmill and, in 1807, a gristmill. Water Street, pictured above around 1910, was the main downtown business section along the west branch of the Owego Creek. In addition to the mill, it had a general store, a creamery, a blacksmith shop, and a church. The Corners at Jenksville, pictured below, was a busy place. The post office, however, closed in 1904. (Courtesy of Thomas McEnteer.)

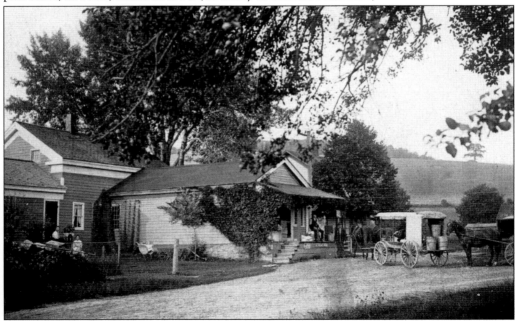

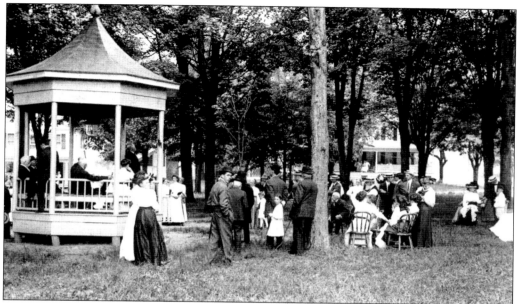

Once called Upper Jenksville, Laban Jenks was the first to settle this area. However, it was John J. Speed, who came in 1806, who the town was named after. The Speeds built several mills, a store, and maintained the post office. The town is located in the northeast corner of Candor and is shared with the towns of Candor and Berkshire in Tioga County and Caroline in Tompkins County. Speedsville's original pagoda, pictured above around 1910, was a gathering place where the community celebrated special events. The Coleman General Store, pictured below, was built in 1902 by Robert Rouse. The arches on the side porch had the symbols of the Independent Order of Odd Fellows, the Masons, and the Grange built into them. There was a large dance hall on the upper floor; in the back was a feed store. This place burned in 1928. (Courtesy of Thomas McEnteer.)

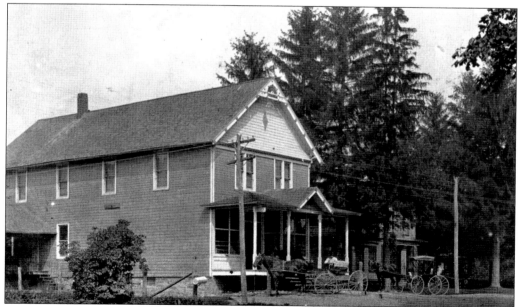

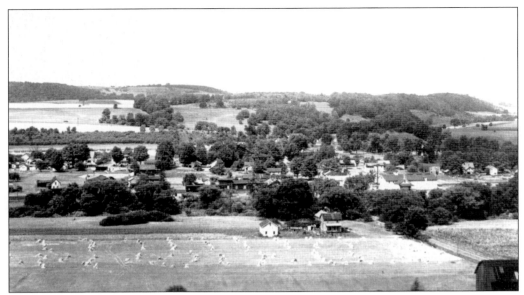

Berkshire lies just over the hill to the east of Candor. Named after Berkshire County, Massachusetts, Berkshire in Tioga County, New York, was settled between 1790 and 1791 in a location that was originally known as Brown's Settlement. Today the town has approximately 28 properties listed on the New York State and National Registers of Historic Places. Berkshire's Main Street, pictured below around 1900, sported the local livery, a grocer, and a dry goods mercantile all in one. Other businesses were next door. (Courtesy of Thomas McEnteer.)

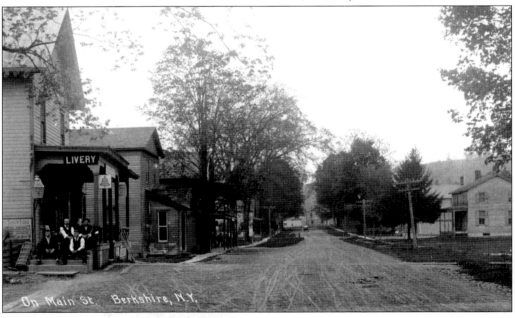

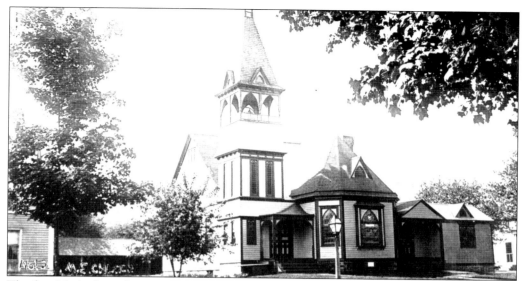

The first Methodist religious meeting in Berkshire was held in 1808 by Rev. George Densmore. It was called a night-watch service. In 1825, a church was organized, and construction got underway in 1827. Later the church was sold and the new church pictured above was built in 1889. (Courtesy of Thomas McEnteer.)

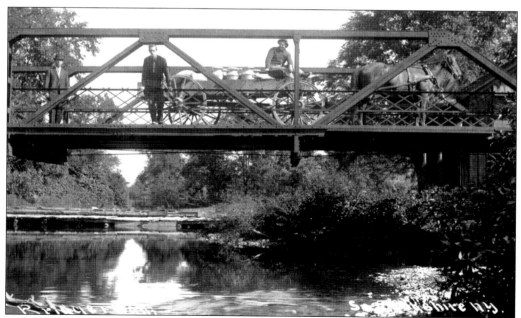

Berkshire Bridge was put to good use by farmers taking milk to the creamery. The dam under the bridge provided waterpower for mills. By the 1860s, Berkshire's landmass was more suitable to dairy farming than growing grains as originally hoped. (Courtesy of Thomas McEnteer.)

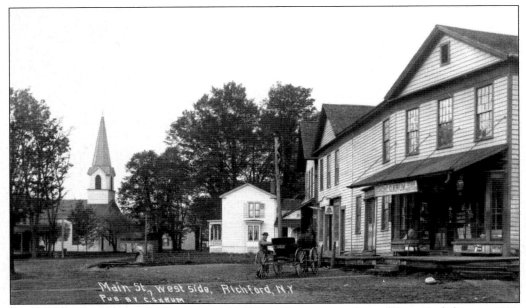

Richford, located in the northeast corner of Tioga County, was formed from Berkshire in 1831. The first town meeting was held at the Rich Hotel. The Congregational church, pictured on the left, was built around 1854 and continues to be a center for community activities today. (Courtesy of Thomas McEnteer.)

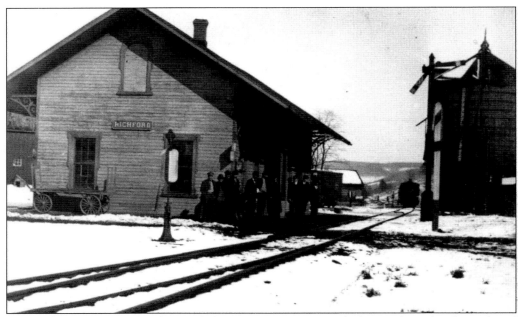

The Lehigh Valley Railroad provided transportation not only for goods to be shipped and brought into town but also for people to move about more freely. The largest engines were called the "twenty-hundred" and were used on the milk train and heavy fright or coal runs. (Courtesy of Thomas McEnteer.)

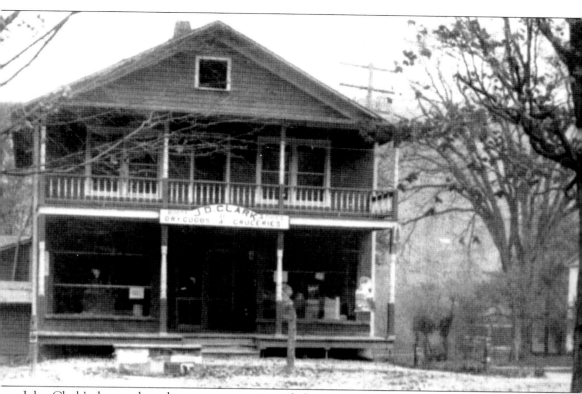

John Clark's dry goods and grocery store, pictured above around 1900, was one of several that operated in Richford. (Courtesy of Thomas McEnteer.)

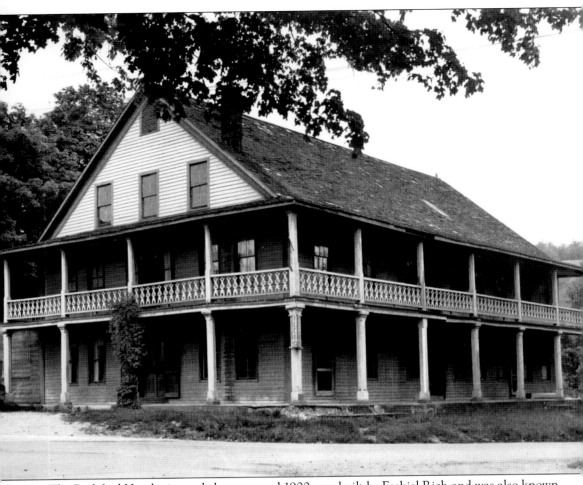

The Richford Hotel, pictured above around 1900, was built by Ezekiel Rich and was also known for a time as the Rich Tavern and even the Old Abby. The building burned in 1991. (Courtesy of Thomas McEnteer.)

BIBLIOGRAPHY

Dieckmann, Jane Marsh, ed. *The Towns of Tompkins County*. Ithaca, NY: DeWitt Historical Society of Tompkins County, 1998.

Gay, W. B., ed. *Historical Gazetteer of Tioga County, New York, 1785–1888*. Syracuse, NY: W. B. Gay and Company, 1888.

Henry, Carol A. *Village of Candor: Yesterday and Today*. Candor, NY: Carol A. Henry Ink, 2000.

Jordan, Mary. *The Pictorial History of Speedsville*. Self-published, 1995.

McEnteer, Thomas C., ed. *Seasons of Change: An Updated History of Tioga County*. Tioga County Legislature, 1990.

U.S. Department of Agriculture. *Soil Survey: Tioga County, New York*. Cornell University Agricultural Experiment Station, 1953.

Weber, Donald F. *A Chronological History of the Town of Candor, N.Y.* Vol. 1 Candor, NY: Self-published, 1994.

ACROSS AMERICA, PEOPLE ARE DISCOVERING
SOMETHING WONDERFUL. THEIR HERITAGE.

Arcadia Publishing is the leading local history publisher in the United States. With more than 3,000 titles in print and hundreds of new titles released every year, Arcadia has extensive specialized experience chronicling the history of communities and celebrating America's hidden stories, bringing to life the people, places, and events from the past. To discover the history of other communities across the nation, please visit:

www.arcadiapublishing.com

Customized search tools allow you to find regional history books about the town where you grew up, the cities where your friends and family live, the town where your parents met, or even that retirement spot you've been dreaming about.